Brooklyn

Brooklyn

Historically Speaking

John B. Manbeck

Charleston London

THE
History
PRESS

Published by The History Press
Charleston, SC 29403
www.historypress.net

First published 2008

Manufactured in the United States

ISBN 978.1.59629.500.1

Library of Congress Cataloging-in-Publication Data

Manbeck, John B., 1931-
Brooklyn, historically speaking / John Manbeck.
p. cm.
ISBN 978-1-59629-500-1
1. Brooklyn (New York, N.Y.)--History--Anecdotes. 2. Brooklyn (New York, N.Y.)--Social
life and customs--Anecdotes. 3. Community life--New York (State)--New York--History--
Anecdotes. 4. Historic sites--New York (State)--New York--Anecdotes. 5. Social change--
New York (State)--New York--History--Anecdotes. 6. New York (N.Y.)--History--Anecdotes.
7. New York (N.Y.)--Social life and customs--Anecdotes. I. Title.
F129.B7M265 2008
974.7'23--dc22

2008023774

Contents

CONTENTS

Foreword

History is who we are and why we are the way we are.
—David C. McCullough

History speaks longingly in the pages of the *Brooklyn Daily Eagle*. Particularly these days, in the early years of the twenty-first century, it speaks of events major and minor, of people big and small, against the backdrop of a monumental, unprecedented renaissance being covered in current news and feature columns. John Manbeck's "Historically Speaking" column and the daily column "On This Day in History" often recall a kinder, gentler era when everything seemed simpler. From coverage of world wars to high school sports victories, there seems to be a bittersweet naiveté between the lines of reprinted *Brooklyn Daily Eagle* articles from past eras.

Brooklyn, the "other" borough of New York City; Brooklyn, which built a unique identity as a bold, proud city unto itself during the rapid growth of the decades that closed the nineteenth century; Brooklyn, which reluctantly, in a close public vote, merged into Greater New York in 1898. Then, in the mid-twentieth century, Brooklyn watched painfully as the beloved Dodgers struggled year after year to overcome their nickname, "Bums," making their few victorious seasons all the sweeter.

The original *Brooklyn Daily Eagle* recorded Brooklyn life as local news that, today, fascinates a large part of our readership in its yearning for the past. Indeed, the revival of the *Brooklyn Daily Eagle* name brings with it an homage to nostalgia. When the original *Brooklyn Daily Eagle* folded in 1955, the *Brooklyn Daily Bulletin* was started on a more modest scale and continued publishing into the 1990s.

Founded in 1841, the original *Brooklyn Daily Eagle* was one of the most famous and beloved dailies in the United States. In 1996, the revived *Brooklyn Daily Eagle* merged with the already-existing *Bulletin*. Thus, the *Eagle*

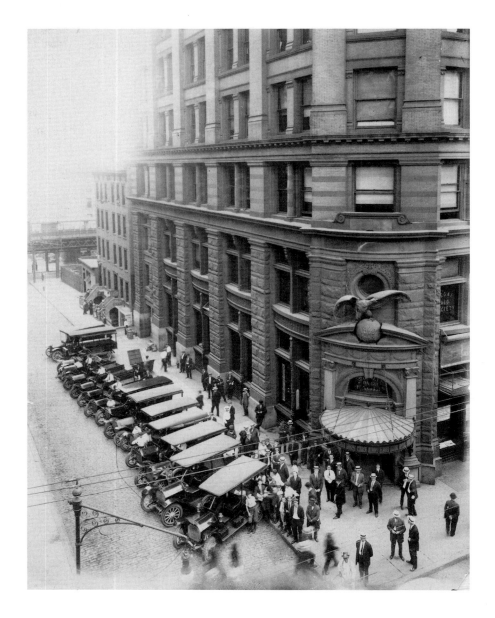

The *Brooklyn Eagle* building on Johnson Street, 1920s. *Brooklyn Public Library, Brooklyn Collection.*

and *Bulletin* have published continuously since 1841, reaching the most influential and involved audience in downtown Brooklyn, a readership split among residential communities, civic and political leaders and the professional workforce.

Since its revival as a daily, each edition of the *Eagle* publishes local news and feature items. Additionally, "On This Day in History" reprints items from the original *Eagle* that pay tribute to the rich story of Brooklyn and the people who called Kings County home. John Manbeck's "Historically Speaking" column expands this historical coverage.

The *Brooklyn Eagle* and its readership bask in this collection of gems written by Professor Manbeck, and we marvel at the relevance his articles bring to those who love Brooklyn today. And ever since we brought news and history to our ever-growing website, www.brooklyneagle.com, Professor Manbeck's features have reinforced our cherished motto: "All Brooklyn. All the time."

Dozier Hasty
Publisher, *Brooklyn Eagle*

Introduction

Brooklyn is unique, a nonpareil, but often misunderstood. Strangers warily visit Brooklyn expecting a phenomenon slanted to images in films or books. They hardly expect civilized provincial communities. Of course, today one can avoid hypothetical dangers by riding an open deck of a bus to see the official sights of northern Brooklyn. From that lofty perch, one flies by DUMBO, the proposed Brooklyn Bridge Park, Arabic Atlantic Avenue, the controversial site for the Brooklyn Nets arena, Grand Army Plaza and the Brooklyn Museum of Art. The bright chatter from the guide allows the tourist to feel enlightened about Brooklyn.

But the borough has a deeper history that can only be absorbed by walking through the neighborhoods, talking to the residents, shopping and dining at diverse locations. As new residents replace refugees from nineteenth-century political and natural chaos, traditions merge with innovations to bring a vibrant freshness to the borough. While history has vanished in some sections, in others the historical aspect rings with renewed vitality.

As the western tip of Long Island, water laps at Brooklyn's shores, providing transportation from rowboats and canoes to sailing skiffs and cruise liners, from industry to parkland, from sylvan vistas to illuminated amusements. The original Dutch settlers sought tranquility on their huge land grants; today, Brooklynites seek escape from the business world across the East River. Those in the service sector guarantee the needs of millions of Brooklynites.

Since its settlement by the Dutch, Brooklyn has occupied a distinctive role as a retreat and then as a suburb in the nineteenth century, when New Yorkers *discovered* its bucolic charm. From its convenient bluff overlooking the island city on the other side of the East River, Brooklyn established its independence and then grew with annexed adjacent towns. As the heart of the original 1836 city, Brooklyn Heights assumed the role of doyenne to communities in the east, west and south.

The original divisions of Brooklyn have grown from six official land segments into over ninety random neighborhoods created through settlements and planned developments. The sweep from agricultural to suburban was not completed until after the mid-twentieth century, when low-lying lands were filled in to develop southern communities there. Into each of these neighborhoods compatible ethnic groups settled, introducing a layered history atop the original Dutch, English and German communities.

While most of Brooklyn emerged as a business class, some neighborhoods appeared more vibrant than others. Art and culture, sponsored originally by upper gentry, prospered in the mid-nineteenth century in northern Brooklyn. Around the same time, a ribald amusement area appeared on Coney Island at the southern tip of the Town of Gravesend. On the periphery of the county, heavy industry and shipping brought profits to Brooklyn. Today, with the eventual gradation of labor, Brooklyn has emerged as a diverse megalopolis driven by white-collar business and populated by diverse residents. While some neighborhoods attempt to preserve their history and culture, others adapt to new ethnicities. Areas in the north closer to Manhattan are evolving with urbanity and appropriately oversized architecture amid complex grid patterns.

So with Brooklyn growing relatively more significant, my columns for the latest re-creation of the *Brooklyn Daily Eagle* have examined its history in "Historically Speaking." I started writing the column at *The Brooklyn Paper* and then moved over to the *Eagle*. Today's Brooklyn is a vastly different place from its sylvan origins. It has survived urbanism, war, depression and poverty, gentrification, corruption and deceit, glamour and glory, crime and punishment and discrimination. Brooklynites today have contributed their own history. I would like to think that Brooklyn stands stronger today and that it promises a more attractive future.

The topics that I have explored in my columns initially were relevant to news topics of the day and unrelated thoughts of the moment. Here I have given them a relationship to each other in the hope of understanding more about the city in which I was born. I hope this book reveals the complexity of Brooklyn's multiple personalities.

As the official Brooklyn Borough historian, appointed by Borough President Howard Golden in 1994, I addressed the topic of history and its relevance to Brooklyn. New York State has created a mandatory role for county historians who have the responsibility of gathering and promoting local history. I felt that popularizing history made it attractive and interesting to the public.

My educational roots lay in the field of philology: I was an English and journalism teacher. However, I had minored in American history

and had founded the Kingsborough Historical Society at Kingsborough Community College, whose mission dealt with the history of Brooklyn's southern shore.

My early examination of Brooklyn's history spurred these original columns. I wrote the thoughts on history that I had formulated as borough/county historian. Subsequent columns cluster around a theme or subject that I examined. Dates of the published column or web entry precede each article so that columns can be related to the time of their creation.

My appreciation and gratitude is extended to my first-line proofreader, my wife, Virginia, and to the editors at The History Press, particularly Jonathan Simcosky. For the archival graphics, I thank Joy Holland of the Brooklyn Public Library's Brooklyn Collection and Julie May of the Brooklyn Historical Society. Gail Smollon and Monica Startari helped solve several technical difficulties. Of course, without the *Brooklyn Daily Eagle* staff, Production Manager Artur Ramos and Layout Designer Rose Deschenes, and its publisher, John Dozier Hasty, this book would have never reached fruition.

Part I

Historically Brooklyn

History Happened Here

March 18, 2002

H istory is not simply dead, as in "you're history." History is very much
alive. It is today and tomorrow, not specific dates. History moves
faster than the speed of light these days. Yesterday's past meets tomorrow's
predictions today. Brooklyn watched closely as history unfolded across the
East River on September 11, 2001.

The History Channel, one of the more popular cable channels, has
claimed that history occurs on the fifteenth day after an event. On day
one, the event is news; on days two through fourteen, the event is edited,
discussed and analyzed. On day fifteen, it becomes history.

Sometimes the process is reversed. A historical person may find a new
life—a new interpretation—and become a contemporary icon. Mayor Rudy
Giuliani stood on the verge of history when September 11 entered his life.

Brooklyn is a hotbed of history. Its past includes a laundry list of heroes
and rapscallions. Yet it also reinvents itself to offer new interpretations of
old opinions. Our fundamental history goes back more than 350 years, but
each person who moves to Brooklyn—and the numbers keep rising—puts
a new spin on its history.

No one thinks of Brooklyn—or even of New York City—as a historic
town. Philadelphia, yes; Boston, yes; Charleston, yes. Dr. Kenneth Jackson
of Columbia University notes that New York and Brooklyn, where he has
ancestral roots, created more history than any other city. Brooklyn Heights,
he stated in *Crabgrass Frontier*, was America's first suburb.

Some of our historic moments have been celebrated publicly: the
centennial of the Brooklyn Bridge; the consolidation of the cities of Brooklyn
and New York; and the centennial birthdays of the Brooklyn Public Library,
the Brooklyn Museum of Art and the Brooklyn Children's Museum. Just
last summer, more than five thousand people thronged into Prospect Park to
watch reenactors honor the Battle of Brooklyn and jeer British troops as they
marched through Park Slope to fight at the Old Stone House.

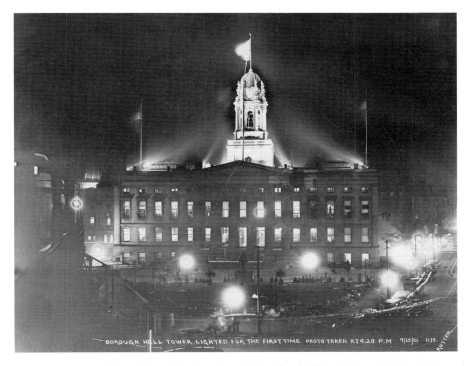

Brooklyn Borough Hall all lit up for first time, 1920. *Photo by Edward Rutter. Brooklyn Public Library, Brooklyn Collection.*

These events demonstrate the most visible interpretations of history. More subtle histories happen daily. A local business observes an anniversary. A couple celebrates fifty years of marriage. A woman lives past one hundred. The Historic House Trust preserves a landmark-designated house that had been vandalized (the Lott House). Gateway National Recreation Area restores the former reception room and control tower at Floyd Bennett Field (Ryan Visitors Hall). A derelict theatre is renovated into a high-tech movie house (the Pavilion, formerly the Sanders in Windsor Terrace). The woodlands in Prospect Park are replanted. The promenade in Brooklyn Heights is reconstructed. A former borough president celebrates a birthday. It is all history.

History surrounds us. Sometimes it glows like a sparkler for a few seconds and then vanishes into the darkness. But when it is in our midst—such as the buoyant celebration of the Statue of Liberty restoration or the festive Caribbean festival on Labor Day weekend—it is as glorious and thrilling as a Sousa march. And he, too, was Brooklyn's history.

When the band music and flying flags flash in our memories and we forget our wounded pride caused by change and uncertainty about our future, history is our bulwark. History is civilization's memory. Without it, we have amnesia. With it, we have a past *and* a future.

In the long run, it is nice to know that our history is here, next to us, surrounding us, with us. It makes us proud to know Brooklyn, to know even a bit of its history, to know that "History Happened Here."

Researching
Brooklyn Online

March 20, 2008

History, I feel, never lapses. It remains in our past, most certainly, but also in our present (where it will be history tomorrow) and in our future. Considering this point of view, I speculated on our resources of tomorrow. Will we still consult books? Will we hold newspapers? Or will our hands be cleaner?

Obviously, much of our initial research has gravitated to the computer, although some feel that research stops at the screen. If so, what is out there to help us research history? And how accurate is it?

Websites are the most logical starting point. After typing in "Brooklyn, N.Y.," my PC told me that I have "124 results stored on my computer." Surfing through the sites, I could tell that a large number of these "results" were commercial sites, including those for real estate. (Brooklyn is still a hot market, in case you haven't heard.) But where could I find useful, factual information?

I started with a search for "Brooklyn Neighborhoods," which I found emanated from 1010 President Street, but it was stuck between 1995 and 2003. What's more, the creator had merely copied pages from the 1939 publication, *WPA Guide to New York City*, readily available in my neighborhood library or bookstore.

More useful were three semiofficial sites: Brooklyn Tourism and Visitors Center; Brooklyn On Line, produced by Wynn Data, Ltd. (copyright 1996–2007); and Brooklyn About, a product from *about.com*, a website owned by the New York Times Company. The Tourism and Visitors' Center is an arm of the borough president's office, which has its own website at www.Brooklyn-USA.org. The Kings County clerk's office also has its own site, as does the Brooklyn Chamber of Commerce and the Brooklyn FDNY. A private site, All About Brooklyn, is run by Brooklyn Dot Com.

Most Brooklyn-based organizations have sites for publicity and information: the colleges—Brooklyn College, Kingsborough Community College, Pratt,

Polytechnic, Long Island University, St. Francis and St. Joseph's—along with Erasmus High School and Brooklyn Friends' School.

Hospitals, both public and private, have websites with information for consumers: Woodhull, Brookdale, University Hospital of Brooklyn, Kings County, Brooklyn VA Hospital, SUNY Downstate, InterFaith, New York Methodist, Maimonides and Brooklyn Hospital. Even Green-Wood Cemetery has one, in case you want to look to the beyond.

Cultural institutions promote themselves via websites: Brooklyn Public Library, the Brooklyn Museum of Art, Brooklyn Botanic Garden, Brooklyn Academy of Music (BAM), Brooklyn Resource Information Center for the Arts (BRIC Arts), Brooklyn Children's Museum, Gallery Players, Prospect Park, New York Aquarium, Brooklyn Lyceum, the Brooklyn Historical Society and the Williamsburg Cultural Center. The Brooklyn Cyclones promote themselves, as does the Brooklyn West Indies Carnival.

Brooklyn's religious and social organizations have sites for the Roman Catholic Diocese of Brooklyn, the Franciscan Brothers, Congregation Beth Elohim, the Brooklyn Masonic Temple and the Brooklyn Tabernacle.

Then there are newspapers beyond the *Brooklyn Daily Eagle* and *The Brooklyn Paper*. *Daily Heights* reports news from Prospect Heights, and *Daily Slope* reports on Park Slope news. The Notable Names Database (NNDB), run by Soylent Communications, features lists of Brooklyn schools and people. Brooklyn NY Links runs an eye-watering list of Brooklyn links in tiny 6-point type, while the "2007: 11 Most Endangered Places" website catalogues at-risk locations on Brooklyn's industrial waterfront.

Among myriad restaurants are Grimaldi's Pizza and Peter Luger's Steak House. For a change, there's the Brooklyn Rap Dictionary, and on YouTube you can see the Dyker Heights Christmas celebration in all its glory.

Under blogs, Brooklyn is represented with several real estate blogs ("All About Brooklyn"); brooklynguyloveswine.blogspot.com, a wine and food blog; the Brooklyn Bushwick Blog (where you can find an archive: "Safe from Brownstone Nazis"); the weblog, "Across the Brooklyn Bridge"; the Brooklyn Heights Blog; and the Cobble Hill Blog. The Gowanus Lounge has a blog with its slogan: "Only the Blog Knows Brooklyn." The Atlantic Yards Report has news about the Nets.

Adventures in Brooklyn and BK 11201 recount personal tales with pictures. Brooklyn Enthusiast deals with food and recipes, as does Bread, Coffee, Chocolate, Yoga and All in Brooklyn. Frisket of Hicks Street recently became Frisket of Main Street: it's about a dog. Two others have Brooklyn Bridge pictures: Never Sleepist and Sam I Am.

To me, most of the material I encountered in blogs has been gossipy and unreliable. While the websites are more substantial, information must be further researched in, say, a book.

Passing of Brooklyn

January 3, 2008

Approximately 110 years ago, Brooklyn, demoted from a city to a mere borough, suffered an ignominy that deserves to be remembered annually. Diplomatic politicians use the term "consolidation" to describe the day that the cities of Brooklyn, New York and Long Island City were joined together with Staten Island and sections of Westchester and Nassau Counties to create Queens and the Bronx. Here is how the *Brooklyn Daily Eagle* covered the transfer of power on December 31, 1897, and on the following New Year's Day.

In a lead article headlined "[Brooklyn] City Hall Ready for To-Night's Guests," the anonymous reporter wrote the subheading "The Reception Entirely Informal and Everyone Invited" in reference to the "memorial" service to be held at Brooklyn Mayor Frederick Wurster's offices.

In spite of the heavy rain, a large "assemblage" appeared. No entertainment was planned, for it was hardly a festive occasion. Plants and orchids, supplied by the Parks Department, occupied every corner of the third-floor courtroom. Mayor Wurster presided over the ceremonies as the new borough president would not take office until midnight.

Sidebar articles cited Brooklyn's problem debt of over $85 million. While the City of Brooklyn owed over $66 million, the Town of Gravesend (under John Y. McKane, supervisor) owed over $1 million, the largest debt of the five remaining independent towns.

Another column anticipated the plans of the mayor-elect of New York City, Robert Van Wyck. The opening week of his administration would be largely ceremonial and custodial since the municipal assembly (city council) would not be in session for that week.

By January 2 (no publication January 1), the *Eagle*—which had been editorially opposed to the consolidation—headlined "Farewell to City, Hail to Borough" in 48-point type. "Calmly and with dignity, Brooklyn passed from the state as an independent city into Greater New York." Among the

invited guests, the Society of Old Brooklynites stood out as guests of honor. (The group still participates in historic Brooklyn events.)

Six of Brooklyn's former mayors attended, including Seth Low, who would later be elected mayor of Greater New York. Though the visitors behaved well, they "could hardly have been said to be merry." But they were "patriotic and ready to appreciate everything" and exhibited a "pride that...should be an incentive to make this borough the greatest in the great municipality that was born when the City Hall bell tolled the hour of midnight."

The new borough president, Edward Grout, met the common council. Then, at 8:30 p.m. the ceremony began. Brooklyn's last mayor cited the growth of Brooklyn at the rate of forty-five thousand people a year. He pointed out that, while the city was passing, the borough would grow greater. With misgiving, he alluded to the fact that the people of Brooklyn never had a proper referendum. (The consolidation was engineered in Albany.)

Then he introduced Dr. St. Clair McKelway, who had written *Brooklyn Eagle* editorials against the consolidation, but, in light of reality, said, "Farewell to the City of Brooklyn! Hail the City of New York!" McKelway stated, to loud applause, "In politics the only thing which fails is success, and the only thing which never loses is principle." In summary, he referred to Brooklyn's life as a city: "Brooklyn's finished record as a city is creditable and indestructible."

The evening ended with a poem read by its author, Will Carleton, called "The Passing of Brooklyn," after which the bells over city hall chimed and Brooklyn joined New York forever.

The *Eagle* noted the bright, fresh weather that greeted the new Tammany-backed mayor of Greater New York. Crowds gathered at Manhattan's city hall on January 1, 1898, anticipating "that the government of Greater New York would begin forthwith, a delusion that was soon dissipated."

The new mayor, Van Wyck, was greeted by outgoing Mayors Strong of New York, Wurster of Brooklyn and Gleason of Long Island City, as well as Democrats from around the city.

The deed had been done. Let the new century begin.

PART II

Creating Brooklyn:
1776 at the Old Stone House

Fighting the
Good Fight

August 24, 2006

Recently I visited Boston, one of several "cradles of democracy."
Around that city, many historic reminders dot the Freedom Trail:
graves of Samuel Adams (the brewer), Paul Revere (the silversmith), John
Hancock (*not* the insurance company) and the Franklin family (Ben came
from Boston, but lived in Philadelphia).

Our history books are filled with errors, and one of the most widely
propagated surrounds the fame of Paul Revere. While he deserved his
fame as a craftsman, he also excelled as a father. Between his two wives,
he fathered eighteen children, a feat that leaves one to wonder about his
nighttime rides. Far from being the stalwart, square-jawed American hero,
he more resembled a Hollywood star: Danny DeVito.

According to the poet Longfellow, Revere was the lone rider on that
night in April 1775. Not so. Two others helped him, but their names did
not rhyme with "hear." Revere was the only one captured because his horse
threw him into a patrol of British soldiers. Did he shout, "The British are
coming!"? Would that have made sense when *everyone* was British before the
Revolution? (It is possible that he shouted, "The Regulars are coming!")

Then a few more answers surfaced. The Battle of Bunker Hill—actually
fought on Breed's Hill, another location—turned out to be a skirmish.
And the Boston Massacre? What do you think of when you hear the word
"massacre"? Hundreds? Thousands? How about *five*?

Hardly a massacre. But Sam Adams—who, when Revere warned him,
ran away, leaving documents about conspirators behind (he returned for the
trunk of papers before the British found them)—put a spin on the event, had
an elaborate funeral, alerted the rabble (actually, most minutemen were the
winos of their day; each consumed several flagons of booze for breakfast)
and staged a huge public relations protest against the "massacre."

So where did the *real* American Revolution start? Right here in Brooklyn
over two hundred years ago. And the first major battle of the war took place

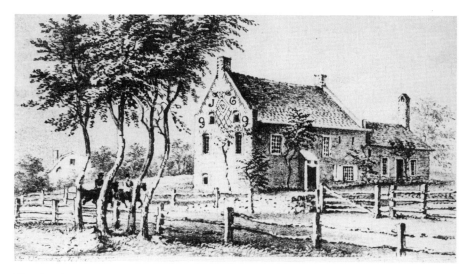

The Old Stone House, formerly Cortelyou-Vechte Mansion. *Brooklyn Public Library, Brooklyn Collection.*

at a house near the banks of the Gowanus Creek owned by Nicholas Vechte. At the start of the Revolutionary War, Charles Carroll, the only Roman Catholic signer of the Declaration of Independence, recruited a brigade of Marylanders to help General George Washington defend Brooklyn. Commonly known as the Battle of Long Island, the conflict between the Maryland irregulars under General William Alexander (Lord Stirling) and the superior professional British and Hessian armies under General William Howe took place in today's Brooklyn.

The farmhouse built in 1699 by a Dutch immigrant, Claes Vechte, had been named because it was the first stone house built in the neighborhood. In 1766, the house was rented to Isaac Cortelyou and was then reclaimed by Vechte. In 1779, Nicholas Cowenhoven inherited the house and sold it in 1790 to Jacques Cortelyou, who gave it to his son, Peter, as a wedding present.

During the Battle of Brooklyn, the house became a fort used by British artillery troops. General Stirling, surrounded by troops commanded by British Generals Grant and Cornwallis, ordered his Maryland troops to attack the house three times, allowing the balance of his troops to cross the Gowanus in the dark and join Washington in the Cobble Hill vicinity. With 250 of his troops killed, he ordered the remainder of the 400 rebels to surrender to the British while he surrendered to a Hessian general.

Washington and his army escaped Brooklyn in the fog of night, permitting the war to continue in Manhattan and conclude in upstate New York.

After the Revolution, the Old Stone House at Gowanus stayed in the Cortelyou family until 1852, when it was sold to Edwin Litchfield, a railroad baron, major landowner and Brooklyn developer. It endured an ignominious future, first as a clubhouse for a winter skating club and for the nascent Brooklyn Dodgers in summer. Then it burned and was razed in 1897. The New York City Parks Department rebuilt it in 1935 as a bathroom.

When the true historical value of the Vechte-Cortelyou house became apparent, it was reconstructed through funds granted by Borough President Howard Golden and reopened as an interpretive center for the study of the Battle of Brooklyn, operated by the First Battle Revival Alliance.

Today, the two-storied Old Stone House exposes more history of the American Revolution than all those apocryphal tales from Beantown Boston.

Brooklyn's Battle of 1776

August 19, 2002

The climax of the musical *1776* occurs when the Continental Congress receives a message from General George Washington that asks, "Is anybody there? Does anybody care?" His missive continues, citing that from his observation post on "Brookland Heights" he sees his five thousand troops facing the British and Hessian armies, twenty thousand strong. The members of Congress blanched as they realized the odds.

This was the army that confronted and routed Washington and his rebels at the end of August 1776, 226 years ago, only seven weeks after the signing of the Declaration of Independence. Both the British and German armies excelled as professional fighting forces. They squeezed the American volunteers into a vulnerable position with a pincer attack. British artillery had barricaded themselves inside a fortress of a building, Brooklyn's Old Stone House, originally the Cortelyou-Vechte mansion. General Lord Stirling and the rebel Maryland regiment attacked the fortification repeatedly.

On August 22, the British army crossed from Staten Island to Gravesend and proceeded through Flatlands and Jamaica and into Flatbush virtually unopposed. The British navy, with more than one hundred ships—over 40 percent of the Royal navy—filled New York Harbor. According to the late John Gallagher in his book, *The Battle of Brooklyn, 1776*, the British command practiced traditional warfare: if an army was outnumbered, everyone picked up his marbles and went home.

Washington's army did not see the battle—the first major conflict of the war—that way. Repeatedly, over the week of August 26 to August 30, Washington's men attacked in suicidal waves, upsetting the British resolve and causing General William Howe to speculate as to whether reinforcements were hidden elsewhere.

With twelve hundred rebels dead and thirteen hundred captive, Howe assumed he had defeated the enemy and did not need to follow through on the attack. But many Americans had escaped across Gowanus Creek to

safety. A week later, when a fog rolled through, preventing Admiral Richard Howe, the general's brother, from moving in with his fleet, Washington, from his Cobble Hill observation post, decided to flee with his troops across the East River to Manhattan.

The American army retreated to Harlem Heights on September 16, ostensibly losing Brooklyn and New York. In November, Washington tried to recapture New York, but faced defeat at Fort Washington. With twenty-eight hundred more soldiers captured, the British held more rebels captive than remained in the American army.

Last summer, a reenactment of this Battle of Brooklyn took place in Prospect Park's Sheep Meadows and at J.J. Byrne Park, site of the Old Stone House in Park Slope. More than three hundred reenactors in period costume fought before an audience of eighteen thousand onlookers. Additional festivities continued at Fort Hamilton in Bay Ridge.

In 2002, "1776 Battle Week" was celebrated, but not on such a grandiose scale. A preview event was held at the Cemetery of the Evergreens on August 11. The opening ceremony, "Memorial Remembrance," on Saturday, August 17, took place on Eighth Street and Third Avenue, followed by an open house at the Old Stone House.

Other events took place on August 24: a tribute at the Prison Ships' Martyrs' Monument in Fort Greene Park; a reenactment of Washington's evacuation from Brooklyn at the Fulton Ferry Landing; a dedication of the Liberty Flag Pole at the New Utrecht Reformed Church in Bensonhurst the same afternoon; and a celebration of the Altar to Liberty ceremony on Battle Hill in Prospect Park. There was also a neighborhood walk to visit local Battle of Brooklyn sites on August 27. The Battle of Brooklyn continues to be remembered annually with similar events.

Considering that this first real battle of the American Revolution—Bunker Hill and Lexington were mere skirmishes—started us on the road to liberty, we should be grateful that those grand old men in Philadelphia finally decided to respond to George Washington's cry for help.

The Downside of War

September 6, 2007

The closing days of August mark America's most illustrious defeat at the Old Stone House in the Battle of Brooklyn, 1776. While General George Washington retreated into victory at Saratoga, British troops occupied Brooklyn and New York. Captured rebels (we were still British subjects until 1782), sympathizers and foreign captives became prisoners of the British in one of the most sordid cases of wartime inhumanity until World War II. Remains of those who died on the prison ships lie in a crypt beneath the Prison Ships' Martyrs' Monument in Fort Greene Park.

Originally named Fort Putnam after Colonel Rufus Putnam, cousin of the American Revolution's General Israel Putnam, the pentagonal fort was constructed under the supervision of General Nathanael Greene. Situated high on a hill overlooking Wallabout Bay, it commanded a view of the harbor but was also vulnerable to enemy attack.

Fort Putnam was renamed Fort Greene for Nathanael Greene in 1812 and maintained a garrison until 1815. An earlier fort of the same name stood at State and Schermerhorn Streets. By 1842, parkland surrounding the fort had been purchased by the City of Brooklyn from the Cowenhoven family. Named Washington Park, it was the city's second public park. By the 1890s, the neighborhood, founded in 1639 by immigrant Peter Alberti, had evolved into Brooklyn's prestigious silk stocking district.

Meanwhile, back at the Revolution, the British abandoned New York in 1783. Wallabout Bay had been the graveyard for decommissioned ships and had been converted into nautical prison ships. For seven years, an average of 10 prisoners incarcerated there died daily as a result of maltreatment by their captors. While total figures remain elusive, it is assumed that from 8,000 to 11,500 died in captivity.

The first attempt to honor them centered on a wooden monument erected in Vinegar Hill by the Tammany Club in 1844. The site, largely ignored, was championed by Walt Whitman, who wrote in the *Brooklyn Daily*

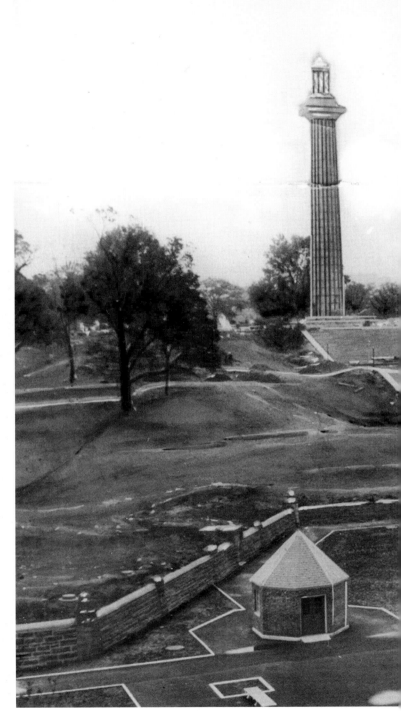

Martyrs'
Monument in
Fort Greene Park,
1930. *Brooklyn
Public Library,
Brooklyn Collection.*

Eagle on August 27, 1846, a request to "reserve at least one spot as a visible token" of their valor.

By 1873, a crypt for their bones covered by a small monument was constructed in Washington Park. Four years after the death of Whitman, Olmsted, Vaux & Company, developers of Prospect and Central Parks, redesigned the park, renaming it Fort Greene Park.

In the 1890s, Brooklyn demanded a more substantial memorial. Stanford White of McKim, Mead & White designed a 148-foot freestanding Doric column, which was the world's tallest at that time. Leading to the column was a 100-foot-wide stairway. Inside the column were a double spiral staircase and an elevator. On the top stood a bronze urn sculpted by A.A. Weinman and filled with an "eternal" flame. At the ribbon-cutting dedication in 1908, Secretary of War William Howard Taft, later the twenty-seventh president, presided over the ceremony.

While initially respected and honored, the park and the monument, also known as Soldiers and Sailors Monument, fell into disrepair and disuse in the later twentieth century. The Department of Parks assumed responsibility for the park, and under Parks Commissioner Robert Moses, the elevator and the staircase inside the column were removed in the 1930s, but the Fort Greene Conservancy mounted a promotion for its total rehabilitation. In 1972, a redesigned park vision emerged.

With promises to reignite the eternal flame for the first time in sixty years, another renovation of the monument was announced in 2005 in a $4.5 million project, with completion promised in the late fall of 2007. (As of 2008, the project is still a work-in-progress with no projected completion date.) A single vertical staircase was rebuilt inside the column, but is not available to visitors. A visitors' center, open Monday through Friday from nine to five, features pictures of the monument, as well as original designs and eight thousand names of victims of the prison ships.

Meanwhile, the Society of Old Brooklynites held its annual service to honor the martyrs on Saturday, August 25, 2007. As we celebrated Brooklyn's role in the American Revolution, the bones buried beneath the Fort Greene monument stood as a tribute to their bravery and to the pain of their valor.

The Mayor of Stirling Visits Brooklyn

April 26, 2007

The mayor of Stirling visited Brooklyn to celebrate Tartan Day, April 6.

So what?

That's our annual celebration of Scottish culture.

Big deal.

He marched in the Tartan Day parade on April 14.

Who cares?

Perhaps the name "Stirling" didn't ring a bell. Stirling, Scotland. As in Lord Stirling, Earl of Stirling.

That's a funny way to spell "sterling."

As in William Alexander.

That's a funnier way.

As in the Old Stone House. As in the Battle of Brooklyn. Or, as the Scots say, "the War for U.S. Independence."

Don't get revolutionary about it.

In spite of his royal title, Alexander fought under General George Washington against Howe's redcoats. Alexander's heroic act in the Battle of Brooklyn—some say Battle of Long Island—saved the day, and the war, for all Americans. Without Alexander's courage, we would pledge our allegiance to the queen today.

God save the Queen!

Alexander commanded four hundred Marylanders to attack over two thousand British artillery soldiers fortified in the Old Stone House in August 1776. The Brits were under the command of Lieutenant General Lord Cornwallis.

I remember that name from school.

The Marylanders, mostly Germans who enlisted in Pennsylvania, attacked again and again. By logic, the rebels should have surrendered, considering the odds and their high losses. Instead, they charged again as the light cannons answered their musket fire.

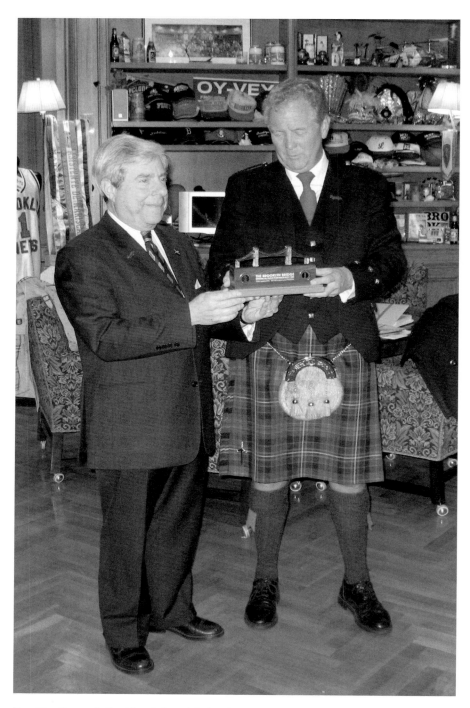

Brooklyn Borough President Marty Markowitz and the mayor of Stirling, Scotland, Councilor Colin O'Brien. *Photo by author.*

Now that's scary!

The following is a description of the action as written by the late John Gallagher in his book, *The Battle of Brooklyn, 1776*:

> *There was only one way for Stirling to stop the inexorable British tide, and that was to attack. Into a rain of British fire the Marylanders charged, and Cornwallis recoiled, stunned by the unexpected rebel onslaught. Though the ground became littered with dead and dying Maryland militia, Stirling formed them up again. Again, they attacked, closing up the line when comrades fell, reforming and attacking again, their numbers diminishing by the minute. Six times Stirling charged, and twice the assaults drove the British from the stone house.*

In the end, the Marylanders broke into small groups to try to escape. The Marylanders lost 256, with over 100 wounded and captured. Only 10 escaped back to Washington's lines in Cobble Hill. Stirling, captured, refused to surrender to the British but surrendered his sword to the German Hessian commander. Later, General Cornwallis remarked, "General Lord Stirling fought like a wolf."

Now that was an exciting battle!

And Lord Stirling, William Alexander, was an exciting American.

But you said he was Scottish. Aren't the Scots English?

The Scots had their own fight with the English. In 1746, Scottish highlanders fought the British in their own revolution. The English won that one. And Alexander had his personal fight with London. He came from a long line of Scottish lords, but when he applied to Parliament for his peerage, they refused. So he declared himself a lord.

Very independent of him.

He had a title and owned Stirling Castle in Scotland. Ironically, a British general who fought him in Brooklyn, General James Grant, became governor—or custodian—of Stirling Castle.

That's called getting even.

But now that America has achieved its independence and we're on friendly terms again, the "provost" or mayor of Stirling is sitting—no, standing—for tea with the borough president of Brooklyn. His full title is Councillor Colin O'Brien, and he wears a kilt in the colors of his mother's family.

O'Brien had visited Brooklyn's William Alexander School, Middle School 51, named after his countryman, and the Old Stone House in J.J. Byrne Park in 2006. His visit in 2007 included the school again and Stirling Park, formerly Fort Stirling, off the Promenade in Brooklyn Heights.

Guess he was proud of Mr. Alexander.

Alexander's Maryland Brigade has been called the Immortals. An anonymous pundit proclaimed that "the Declaration of Independence that was signed in ink in Philadelphia was signed in blood in South Brooklyn."

Pundit?

At the official Borough Hall meeting attended by Mrs. O'Brien, Brooklyn Borough Historian Ron Schweiger and myself, President Markowitz gave the provost a model of the Brooklyn Bridge, while Provost O'Brien reciprocated with a framed photograph of the Stirling Castle in Scotland.

With a smile and a handshake, the two executives declared everlasting peace and future accord.

Amen.

A Brooklyn for All Time

May 13, 2002

When touring Roman ruins scattered about Europe in the wake of their army's conquests, I conceived of filing for a grant to uncover Roman artifacts in Brooklyn. It would guarantee a stipend for a lifetime. Then I looked around my Brooklyn Heights neighborhood. Maybe it wouldn't be so futile after all. Brooklyn's official architecture suggests a very visible Roman legacy.

After the American Revolution, the newly tax-free citizens in upstate New York chose city names of ancient Greece and Rome (Ithaca, Rome, Syracuse, Troy, Utica) rather than copy hated British names. The city that filled Kings County also sought a classical image. It was realized in the new city hall.

In place of the Georgian design of the colonists, architects turned to a more regal and imposing form. The provincial design of city hall in Manhattan—a rustic *hôtel de ville*—would not do for Brooklynites, according to Brendan Gill. The favored design for official buildings here became Greek revival and resembled Roman temples.

After Brooklyn's incorporation in 1834, city fathers conceived of a Roman palace for their seat of government. The first stage of the original structure was completed in 1846. Today, facing the Brooklyn Bridge, it stands in regal splendor with its broad array of steep steps rising to a colonnaded entrance. What could be more Roman?

Inside the temple, another marble staircase climbs to the European first floor, where mayors and borough presidents have had offices. The street-level floor originally housed security services, as well as holding cells for prisoners who were about to be tried in the second-floor courtroom, the former chambers of the common council.

To maintain the classical theme, oil portraits of many city mayors and justices lined the walls. George Washington, whose portrait still hangs outside the former courtroom, glares down at the new administration. Not

only had he led the fight in the Battle of Brooklyn, but he had revisited Brooklyn in the 1780s and served his first year as president of the United States across the East River in Manhattan. But for a deal between Hamilton and Jefferson, the White House might have perched on Brooklyn Heights.

These formal portraits date back to 1835, from Jeremiah Johnson through Frederick Wurster. Linda Ferber of the Brooklyn Museum of Art was the chief curator of a restoration project undertaken in 1986. Earlier in the twentieth century, the portraits had been removed from the walls and placed in storage, where they deteriorated. After a restoration of the building, the pictures were re-treated and rehung, primarily in the courtroom and the borough president's conference room. They represent a singular, classical period in Brooklyn's history not shared by any borough except Manhattan.

Until 1898, the three New York metropolitan cities were Brooklyn, New York and Long Island City. Today, Brooklyn's Borough Hall, with its regal portrait collection, has the look of a formal metropolitan center. The biggest problem remains that most of the portraits lack identifying names, except through a companion pamphlet. Some paintings have ornate nameplates, but others are bereft. Most do not even list the term of office or the name of the painter.

While the Washington painting remains the most recognizable, according to Ferber, the Jeremiah Johnson portrait—painted by William Sidney Mount in 1839—is the most valuable one. Johnson had been elected Brooklyn's third mayor after his distinguished military service in the War of 1812. Mount, an early portrayer of everyday life, subtly included a watch in the mayor's right hand, an indication of Johnson's concern about the tardiness of his councilmen.

Ferber declined to place a value on the entire collection. Its true value, she said, lies in the collection's inclusion within the historical site of Borough Hall. Its integrity and authenticity make both the building and its contents more valuable.

Borough President Marty Markowitz has a different idea. In a press release he said he wants to democratize Brooklyn's "Capitol" building and allow the public to determine "what artwork should grace the walls of Borough Hall. He suggested that the walls should be lively with pictures of "everyday Brooklynites"—perhaps notable Brooklyn residents, or possibly a photograph of Nathan's in Coney Island or its founder, Nathan Handwerker.

Markowitz has brightened his office by removing heavy drapes and a dull carpet. A copy of a George Washington portrait that dominated the room was famously relocated to a second-floor reception room. Several contemporary photographs add to the building's current image.

The community room has been a locus for revolving art exhibits associated with various community groups. Photographs from a 1990s contest called "Document Brooklyn" decorate several corridors, and black-and-white prints by photographer Tony Velez appear in the hallway opposite the elevators. Scattered throughout the communications offices on the third floor are Coney Island photographs from an earlier exhibit.

While the idea of honoring contemporary Brooklynites is certainly laudable, the question of placement remains an issue. Should photographs of a Bensonhurst block party be mounted next to a classical portrait? What if someone suggests cheesecake pictures, not of Junior's but of glamorous Brooklyn women? The building is classical in scope, which means that the ceilings are high and only oversized paintings make sense in certain areas. Perhaps a commissioned mural would fit, such as the one that lined the walls in the 1940s. The bottom line is to permit the décor to enhance the architecture, not diminish it.

We will look forward to the public art selection tours that Mr. Markowitz promises. Certainly, no borough president portrait or even photograph can be found in Borough Hall and they have run the "Capitol" since Edward Grout was elected in 1899.

Brooklyn Day Lives On

June 2, 2005

Guy Fawkes Day may be important in British history, but Brooklyn has an even more important celebration—except "no gunpowder." It's called Brooklyn Day. Brooklyn Day is unique to New York City history because Brooklyn is the only one of the five boroughs that has its own day. On this day, New York City public schools are closed in Brooklyn. (Parochial schools do not celebrate.) Because many Queens residents moved there from Brooklyn, in 1958 the name was amended to "Brooklyn-Queens Day."

Other boroughs complain, of course. The Bronx wants to eliminate this jingoism in spite of the fact that the Bronx existed as a small portion of Westchester County when Brooklyn Day was born. So far, Manhattan and Staten Island remain mum.

Actually, Brooklyn Day was born "Anniversary Day," just as Memorial Day originated as "Decoration Day." Back in the early nineteenth century, when Protestants ruled Brooklyn, the combined political/religious holiday began. Brooklyn, a suburb of New York, but a full-fledged city in its own right, became known as the "city of churches, baby carriages and cemeteries" because of the abundance of all three.

Not only did the Protestants dictate politics, but they also ruled the financial centers. While Irish Catholics fought their way up the political/social ladder, German Jews sided with the successful Protestants.

Some of the most powerful pastors preached their Sunday sermons on proper behavior in the secular world. Henry Ward Beecher, the most noted name, threw himself into the political issue of the day: abolitionism. So famous was he that President Abraham Lincoln came to hear his standing-room-only sermons, as did Charles Dickens. But there were other clergymen as well, such as S. Parke Cadman.

The Sunday school became a showplace for the future of Brooklyn. Churches encouraged families to send their children to Sunday school by

awarding the children metal badges for perfect attendance. Bible stories supplemented the sermon.

The Sunday School Union grew in numbers and strength. It appealed to Albany for recognition, and the politicians recognized the political reality. Shortly before the Civil War, Albany drafted a bill that declared Anniversary Day an official school holiday in Brooklyn, but not a bank holiday. On Tuesday, May 28, 1861, tens of thousands of Brooklyn boys and girls paraded for hours, carrying banners and singing hymns. They celebrated the thirty-second anniversary of the founding of the Sunday School Union in 1816.

The reason for a weekday celebration was obvious. Protestant "blue laws" restricted Sunday activities, and the union wanted a public parade to demonstrate its strength. The law declared Anniversary Day to be held on the first Thursday in June. The parades set churches competing against each other. Parents dressed their children in their prettiest clothes and festooned baby carriages with crêpe paper and ribbons. Thematic floats allowed younger children to ride. With so much activity and tension in the air, Brooklyn children couldn't be expected to concentrate on schoolwork.

At first, even local bands accompanied the marchers, who usually started about 3:00 p.m. and strolled around the blocks adjacent to the church. Everybody loves a parade, so all neighbors of every religion came to watch. Some even joined the march because ice cream was served to participants after the parade finished.

But in 1898, the City of Brooklyn was consolidated into Greater New York. According to the *Brooklyn Daily Eagle*, the new board of education refused to honor the Brooklyn holiday. Letters of protest poured into the board's offices. The day, according to one commissioner, was a universal borough holiday. The board relented, and in 1902 it reinstated the Brooklyn holiday. That year, over ninety thousand children marched past a reviewing stand of national celebrities with members of President Theodore Roosevelt's cabinet, the mayor and governor of New York, commissioners, judges, borough presidents and school superintendents.

So Brooklyn got its Anniversary Day on the New York State book of holidays, and that's what it is called down at the Department of Education. When Brooklyn filled up and the Protestants left town, their churches were sold to other religious groups, demolished or turned into residences. Wealth and religion no longer exerted the power it once did. While celebratory parades could be found in African American communities, they no longer claimed to be borough-wide occasions.

But the school holiday was still law. Why not turn the day into a secular occasion celebrating the unique nature of the city's most populous borough? Brooklyn Day was born. In time, the day and its origins were forgotten

Anniversary Day
Parade, Our Saviors
Church, 1953.
*Photo by Johnny
Kruh. Brooklyn Public
Library, Brooklyn
Collection.*

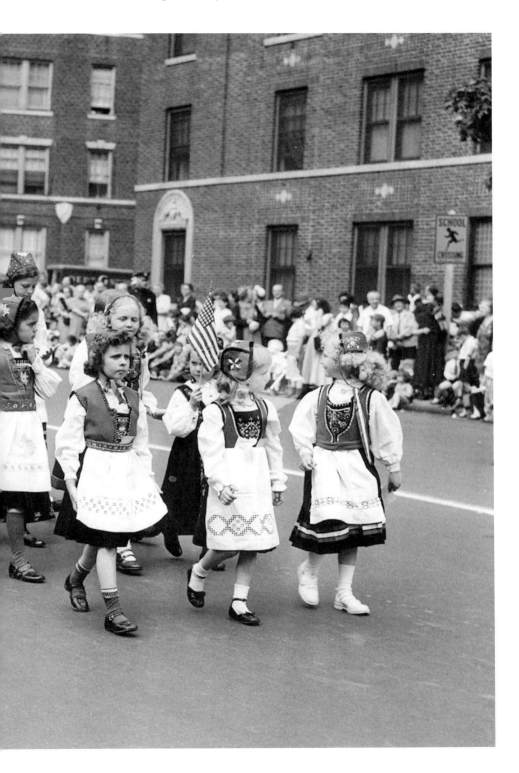

and the celebration was diverted to the weekend, with Borough President Howard Golden's "Welcome Back to Brooklyn" Day. Various neighborhoods across Brooklyn still honor the occasion with different themes. In Brooklyn Heights, "Kids Day" became a day to visit Brooklyn's cultural havens.

Borough President Marty Markowitz is on record to continue recognizing Brooklyn Day. So, on the weekend, two days of festivities will keep Grand Army Plaza active with movies, bands and food. As long as it's on the books, Brooklyn Day/Anniversary Day will be an event to remember.

PART III

Playground of the World

Coney Island Redux

September 21, 2006

Coney Island is having its recurring menopausal moment. Along with headaches and hot flashes, it is enduring its periodic rebirth with new life promised—again. Gentrification is in the air and that's not bad. For it means she's still alive and kicking. But for the old girl, this is nothing new. On the other hand, it's so repetitive!

Most of us have limited vision—limited to our lifetime. That's where history comes in. It reminds us that everything old is new again, as a vaudeville hoofer may have put it. Change is the name of the game, and Coney Island has been changing since it was born.

Take it back to the Native Americans, when the spit of sand was covered with green and trees and "wilde beasties." Then came the Dutch farmers with their cattle, followed by loners who dug up clams for their dinner. Soon, the word got around.

People who could afford the time and the expense of travel—that is, rich people and gamblers—rode horse and carriage out there to go slumming and, perhaps, to cool off. Then boats and, later, steamships got the idea; finally, trains. The excursion fare dipped as the work week shortened. The rich built racetracks to play at and luxury hotels to hide in and pretended to listen to music, far away from the riffraff. But the riffraff and Sodomites gathered there, too, attracted by the golden glow of money. They brought their vices with them and shared them with all.

Entrepreneurs descended on the sandy oasis and introduced new amusements, driving Boss John McKane up the river. Another change. At first, the toys were simple—like a beach. Then, a slide or a tower, or maybe a carousel. The playthings became more complex, and big parks enclosed new, exciting rides, many imported from foreign soil.

The rich soon tired of the lifestyle and went away, bored with the tawdry turn of events. But that made more room for the clerks and union workers on excursion trips. They frolicked on the sands and *oohed!* and *aahed!* at

fireworks, laughed through Steeplechase, slid over to Luna Park and gaped at the white city of Dreamland.

Then the fires of the sideshows got out of hand. More changes. Steeplechase went up in smoke, but it reconstituted itself, for a price. Dreamland seared the heavens and all around. It remained in ashes, no phoenix to arise from them.

Subways came and deposited bathing suit–clad visitors into the sea. They fed on hot dogs, French fries and corn. They splashed in the surf, burned in the sun and lay on whatever patch of sand they could find.

War came, and with it servicemen on leave with gals on their arms, both on and under the boardwalk. More changes! Luna Park burned down and Trump houses went up. Finally, the Aquarium—a sort of phoenix—rose from Dreamland's ashes. Robert Moses brought his Jones Beach vision to Coney Island.

Astroland emerged from Feltman's restaurants, between the Cyclone and the Wonder Wheel. Steeplechase went out of business, the Parachute Ride looming over its remains. Bad times dragged the nucleus of fun down to the rides in Hades.

Then miracles began to change the picture again. Dick Zigun descended from Mount Olympus as Davy Jones or King Neptune or whoever he wanted to be. He led new masses into an oceanic baptism at his Mermaid Parade. And they all came!

Brooklyn Borough President Golden saw a future in a Sportsplex there, but Mayor Guiliani had a bigger vision: a city-financed ballpark (named after the gas god, Keyspan) where the minor league Cyclones would play in the cool and under the lights. But first, another change! We must be rid of the ugly, abandoned Thunderbolt roller coaster.

The mayor built Keyspan Park and the masses came, making the former resort and playground of the world into a commercial Mecca. Lights shone every night. Crowds emerged from the new (but still untenanted) subway terminal and thronged toward the beach, which was still crowded with working people.

The Cyclone, Wonder Wheel and Astrotower make sturdy young people scream in fear. And now, big money and big politicos again talk of Coney Island's future—how they will develop it and bring change. Real estate changed hands again.

But Coney Island's middle name is Change. Rather than have state-of-the-art rides like Disney World for fifty dollars a person, Coney Island needs to relax like the dowager she is. Maybe, just maybe, bring back the old rides, the simpler life. Maybe a museum of the way life used to be. Maybe a re-creation of an old-fashioned amusement park.

It won't bring back the past, but it may help us appreciate the history before we got so busy. Now that another season has eluded us, maybe next year it will happen. (Where have I heard that phrase before?)

Are we having fun yet?

Coney Island Carousels

My "Historically Speaking" column published a four-part history of Coney Island carousels on October 13, November 10, December 8, 2005; and January 19, 2006. Here, I have combined the columns into one essay.

A few years ago, New York City saved the last of Coney Island's carousels with a contribution from an anonymous donor. It is hard to believe that Coney Island alone harbored over twenty-five merry-go-rounds since they started appearing there in 1875. Without this last-minute rescue before the attraction disappeared on the auction block, the famous Abraham Lincoln horse and his equine companions would have been sold individually, like slaves, and been dispersed far from their true seaside home.

Our gratitude goes out to the mayor, who safeguarded the B&B Carousell [*sic*] for future generations. As of now, the B&B Carousell (original owners: Bischoff and Brienstein)—operated for years by Jimmy McCullough, a member of the Tilyou family—will reappear on the Riegelmann Boardwalk close to the former Steeplechase Amusement Park, now Keyspan Park..

The B&B was built in 1919 by Murphy and Nunnally and carved by George Carmel. These hand-carved beasts, valued at auction houses for over $50,000 each, originally sold for $18. The lead horse on the B&B is the armored one with the portrait of Abraham Lincoln on its flank. The original Gebruder organ and brass ring holder are intact.

A similar fate almost befell the Cyclone roller coaster across the street. While operated by the Astroland staff on a ten-year lease, the city Parks Department owns the ride. When rising liability rates threatened to close the Cyclone permanently in the 1970s, the city took it over.

Another Coney Island carousel operates in Prospect Park. Built in 1914 with fifty-one horses, plus lions, giraffes and chariots also carved by Carmel, it was moved to the park in 1952. After restoration, it reopened in 1974. Prospect Park was once home to a more unusual

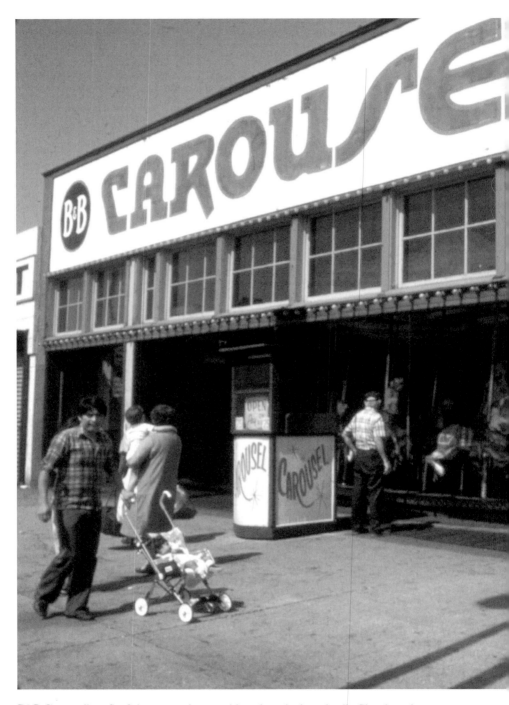

B&B Carousell on Surf Avenue, to be repositioned on the boardwalk. *Photo by author.*

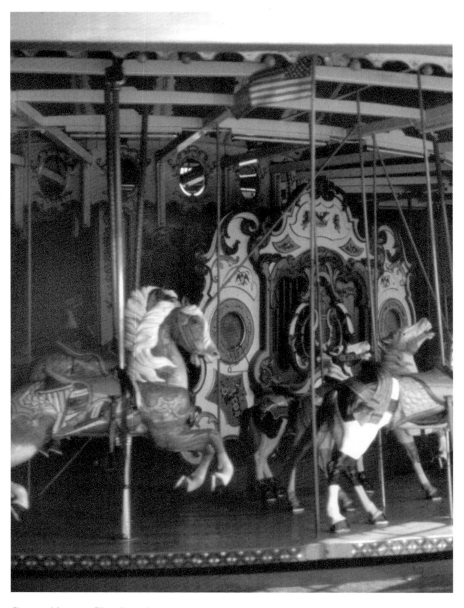

Carousel horses. *Photo by author*.

carousel—a pontoon carousel with balloons that revolved on Prospect Park Lake in 1878.

The carousel concept grew in Europe, so most of the craftsmen emigrated from Germany, Russia or Eastern Europe. In Coney Island, carousel manufacturing thrived between 1875 and 1918. Back then, the horse dominated modes of transportation. But horses also provided entertainment and exciting competitions through the sport of horse racing. The roadway of Ocean Parkway and private driving tracks offered gentlemanly challenges. Then three racetracks opened in the Town of Gravesend, where Coney Island was located. The wooden horses of the carousels became a natural extension of these interests.

The world's first carousels were hand powered, then towed by ponies or donkeys, then steam powered and now they are electric. At least one bicycle-powered carousel has been recorded. Initially, the carved horses imported from Europe looked similar, with mass-produced features and standard trappings. As more creative hand carving evolved in America, varied concepts emerged from Philadelphia, Denver and Coney Island workshops. The Coney model appeared fiercer, with flowing manes and tails, clenched teeth and glaring eyes. The B&B Carousell possessed only one variety of horses, but other classic models showed more imaginative designs, unusual creatures and newer technical innovations.

The carousel, one of the oldest amusement attractions, can be traced to the ancient Byzantines. The word evolves from the Italian *carosello*, an exercise performed by Arab horsemen who had introduced equines to Spain during the Moorish occupation and eventually to all of Europe. As competition and games involving horsemanship developed, the French created a ceremonial tournament called *carrousels*, with richly decorated steeds and riders who would spear rings with a lance.

By the close of the seventeenth century, models of horses mounted on circular platforms taught children the nobility of the animal. The merry-go-round eventually transferred from the playground to the European pleasure gardens, thus becoming an adult amusement. Popular at the spas that suddenly thrived throughout Europe, immigrant groups who thronged to Coney Island, the most renowned American spa, enthusiastically integrated the carousel into amusement areas after the American Civil War. During the nineteenth century, the large numbers of German immigrants helped to popularize amusements, and German craftsmen willingly cooperated. In 1865, Gustav Dentzel opened a factory in Germantown, Pennsylvania, outside Philadelphia, to build carousels, often with a fanciful menagerie. Not only horses, but giraffes, camels, oversized rabbits and the mythical hippocampus—a half horse and half dolphin—emerged from his creative

mind and workrooms. Add to this the British inventor, Frederick Savage, who created the mechanism for the "galloping horses" in 1869, or "flying horses" as the American carousel was originally named.

Jump forward to 1875, when gossip swirled around Coney Island about the new racetracks being built in Brighton Beach and Sheepshead Bay. William and Lucy Vanderveer had just contracted John Y. McKane's construction company to put up a new bathhouse and they needed a new attraction to lure people. They turned to Charles Looff from Germany to create a carousel for the site.

Charles Feltman, a baker, had settled in 1869 in Coney Island, where he opened a complex of restaurants and amusements for Brooklyn's expanding German clientele. In 1880, with his business thriving, he commissioned Looff to create an even bigger carousel for his restaurants. He also constructed an octagonal building to house the new ride on the newly paved Surf Avenue. Looff's horses were of a singular design, either prancing or jumping.

Feltman embellished the Looff design with illuminated jewels on the horses' flanks, and recently invented electric lights brightened the building. By 1903, Feltman teamed with builder William Mangels and carver Marcus Illions to develop the most outlandish carousel in America. With liveried attendants, the ride featured stately horses, carved angels, eagles, lions, sphinxes and snake-headed, winged dragons. Drapery with tassels and buckles decorated in gaudy colors competed with gold-leaf embellishments.

Looff successfully sold carousels to many East Coast resorts from his Gravesend factory. But in 1905, the town government condemned his building for a public project, so Looff moved to Long Beach, California, where he continued his trade making merry-go-rounds for amusement areas from San Diego to Seattle.

By 1890, other entrepreneurs competed in the Coney Island trade and each seemed to add unique letters to the spelling of carousel. Charles Dare moved from New Orleans and founded the New York Carosal Manufacturing Company. He had developed an early roller coaster that was not as successful as that invented by LaMarcus Thompson, so he, too, turned to carousels. Later in the decade, the Bongarz Steam Wagon and Carrousele Works hired Marcus Illions to create new models. Illions also teamed with Mangels, who had invented famous Coney Island rides such as the Razzle Dazzle and the Tickler. In 1898, Mangels developed the mechanism that allowed the horses to rise and fall as carousels circled.

Famous names dot the history of Coney Island carousels. Among the carvers, Marcus C. Illions and Charles Carmel stand out, but Solomon Stein and Harry Goldstein became notable artists as well. All together, they

created carousels that were "most fearful and wonderful masterpieces of art," a reporter noted in 1883. Most of these Jewish artists emigrated from Eastern Europe, where they had carved similarly fearsome faces on arks for the synagogues.

William Mangels drew many of them together. Eventually, he attempted to create a historic Coney Island park with artifacts from defunct rides that he collected over the years, including historic carousels. Back in the 1950s, no interest could be raised. Instead, his legacy is the book he wrote, *The Outdoor Amusement Industry* (1957).

William Johnson, one of his employees from England, brought a British roundabout (carousel), created by Frederick Savage, to Coney Island. In 1898, Mangels created the American version of the Savage mechanism used in Galloping Horse Carousels.

Meanwhile, Frank Bostock, an English owner of a wild animal menagerie, teamed with the Russian craftsman Marcus Illiums in 1894 to spice up the rides. They introduced other animals to carousels. Illiums, a masterful carver of the fiery Coney Island–style horses, settled on Dean Street, where he made his beautiful creations available to Mangels and others.

Bostock also imported a Savage-created portable gondola carousel that rode on a track. Another Savage carousel was the Chanticleer, which decorated the entrance to George Tilyou's Steeplechase Park. Two-seated roosters were mounted on the carousel and were labeled Four-Abreast Bantams, Galloping Chickens and Prodigious Poultry.

The Mangels-Illiums partnership also produced the fastest carousel in Coney at Kister's Restaurant on Surf Avenue, across from Feltman's. When George and Henry Stubbmann wanted one for their new beer garden opposite the Culver Railroad Terminal in 1908, they turned to the same team. The Stubbmann carousel later moved to the boardwalk and, known as the Steeplechase carousel, offered Louis XIV chariots and horses with jewel-studded bridles enhanced by patterns of buckles, bells, rope and fringe.

A year later, Illiums and his family broke with Mangels and offered complete carousel production. The continually evolving hand-carved designs now incorporated flying manes, muscled bodies and latticework harnesses. The horses' heads strained as teeth bared and tongues slid out of mouths. This distinctive reality earned Coney Island artists their unique reputation. With this new independence, at least ten Illium-created carousels decorated Coney Island amusements.

Solomon Stein and Harry Goldstein worked for Illiums, but in 1912 they formed a rival company, Artistic Carousel Manufacturers, to carry on the Illiums tradition. Their best creation was located in the BMT Trolley

Terminal on Surf Avenue. Equally influential in carousel design were Charles Carmel and his family with their factory on Boerum Street.

But the most grandiose Coney Island merry-go-round must have been the El Dorado, which appeared in 1910 on Surf Avenue and West Fifth Street. Built in Leipzig, Germany, by Hugo Hasse for $150,000, it stood in a pavilion illuminated by six thousand lights and featured three platforms in tiers revolving at different speeds. A gigantic organ supplied the carousel music. The top level provided chaise lounges instead of animals. El Dorado stood forty-two feet high and featured horses as well as pigs and other barnyard animals—it was illustrated with carved figures and scenes of rural Germany. Damaged in the Dreamland fire a year after it appeared in Coney, George Tilyou rescued it to be housed at Steeplechase until the park closed in 1966.

The carousels of Coney Island belong to a past unknown today, although the rides are not completely lost to time. While many rides have been destroyed by fires or demolished, several carousels still offer the unique ride we remember. Now the question arises: where are they now?

The first—William and Lucy Vanderveer's carousel built by Looff—stood at the foot of Ocean Parkway. Lucy Vanderveer sold her baths to Balmer after her husband's death. Balmer's Baths and its carousel lasted until the Dreamland fire of 1911.

The "carousal" created by Dare operated from 1876 until 1884, when it was moved to Martha's Vineyard.

The first Feltman carousel built by Looff burned in 1899, but the second—a more ornate one that appeared in 1903—lasted until Astroland replaced Feltman's. The new Astrotower was built on the carousel site, but the ride resumed its life in Flushing Meadows, where it was moved for the 1964 New York World's Fair.

The 1908 BMT Trolley carousel made its rounds at the West Fifth Street trolley terminal until buses replaced the trolleys. Since 1951 it has operated in Central Park.

The Carmel carousel built in 1914 moved to Prospect Park in 1952, while another from the same era was shipped to Bogata, Columbia, in the 1930s.

Luna Park owned two merry-go-rounds: one in 1909 and another in 1924. The latter lasted until Luna's first big fire in 1944.

Bob's Carousel, built in 1926 and found beneath the Tornado roller coaster, was moved to Bertrand Island Amusement Park at Lake Hopatcong, New Jersey, when the Coney Island coaster was torn down.

Two 1927 carousels, among the last manufactured in Brooklyn, could be found at the Prospect Hotel and across from Steeplechase. The Prospect

Hotel one moved to Jamestown, New York, and then to the Los Angeles County Fair. In the 1980s, it was dismantled and stored in Pasadena, California.

Steeplechase's carousel was moved to the Stillwell Avenue train terminal but was vandalized there, so it was dismantled after the 1968 season. The famed Chanticleer was sold to Osaka, Japan, when Steeplechase was demolished.

Back in 2001, the New York Aquarium expressed interest in rebuilding the carousel enclosure for the old Brighton Beach Baths. Originally, the pavilion housed an 1879 carousel built by J. Pickering Putnam, the architect for the Manhattan Beach Baths. In 1959, Hy Cohen removed the merry-go-round and converted the building to a commissary for his baths. Now, perhaps the aquarium can find a carousel to replace the original. The location happens to be the same site as the original—next to the old Iron Tower.

And that brings us back to the B&B, Coney's last remaining and only "Carousell" from 1932. [n.b. The Parks Department has announced that it will be reconstructed in a special building near Keyspan Park.]

Happy rides! And don't forget to catch the brass ring!

Beacon by the Sea

July 27, 2006

Brooklyn, with sixty-four miles of waterfront, has long outbid all the other boroughs as a seaside recreational destination. Now, with Brooklyn Bridge Park in the offing, we find a "piscine" floating in the East River just as Paris has in the Seine. (The Floating Pool Barge materialized in 2007.)

Of course, Brooklyn's seaside is not just beach. It never was. It is beach *and* rides *and* boardwalk *and* baseball. Now there's another "B": a beacon atop the old Parachute Jump. With its transformation from a thrilling ride to a torch for those seeking an honest Brooklyn, we have turned a full circle.

The former Steeplechase Parachute Jump turns out to be the latest in beacons beckoning visitors to Brooklyn. Antedating the ride was the Iron Tower, a three-hundred-foot observation minaret from Philadelphia. Originally constructed for the Centennial Exposition to celebrate a century birthday of the United States in 1876, it was then known as the Sawyer Tower and featured two early Otis steam elevators to transport visitors to the top. At three hundred feet, it exceeded the height of the Brooklyn Bridge. In 1879, the Eiffel Tower built for the Paris Exposition topped it at nine hundred feet.

But Andrew Culver, intrigued by its size, purchased the Sawyer Tower in 1878 and transferred it to Coney Island as a centerpiece for Culver Plaza, his new railway terminal and Thomas Cable's Hotel there. He renamed it the Iron Tower. It was an instant success. And its lights could be seen for miles out at sea.

With the paving of Surf Avenue in 1881, Culver's property was divided and he felt a loss of his rights. In 1893, he sold his railroad to Austin Corbin of the Long Island Rail Road and the Iron Tower to George Tilyou of Steeplechase. Tilyou covered the tower with ads for his amusement park. In the burning of Dreamland in 1911, the steam boilers exploded and the Iron Tower collapsed.

In his early Coney Island days, Tilyou had experimented with an aerial ride in which customers climbed a wooden ladder and rode down to the ocean on a pulley attached to a cable. Around 1907, Dreamland featured the Dumont Airship, from which the pilot parachuted from the Dreamland Pier into the ocean. But it took generations and the New York World's Fair in 1939 before a real parachute would fascinate Coney Island.

The Parachute Jump developed as an outgrowth of America's infatuation with air power and the subsequent training of paratroopers. The idea emerged from the mind of James Strong, a retired U.S. Navy commander. In the 1930s, Strong had observed parachute rides in Russian amusement parks, where customers leaped from a wooden tower. Frequently, though, the jumpers—guided by a single wire—hit the side of the tower. He attempted to eliminate pitfalls in his design, which he hoped to sell to the U.S. government for training purposes, according to researcher Seth Kaufman of Coney Island USA.

By 1936, Strong had created a steel tower with six parachutes, electric motors and eight cables to prevent swaying and crashing into the tower. The two-minute ride transported the "parachutist" to the top of a two-hundred-foot tower with a twenty-foot freefall. He built his first experiments on his Heightstown, New Jersey estate. Strong sold a model to the American army and it is still in use at Fort Bragg, North Carolina.

When he noticed how popular the ride was, he added shock absorbers for the landing and replaced the single sling seat with a more comfortable two-seat metal bench. The chute was enlarged eight feet greater than the military version.

While he sold military jumps to both the American and Rumanian armies, Strong opened his first commercial parachute jump in Chicago at the amusement area, Riverside Park, which he named "Pair-O-Chutes." For the 1939 New York World's Fair, Strong secured sponsorship from Life Savers, which decorated the ride with illuminated candy rings and increased the height to 250 feet, adding six more parachutes. While in Flushing Meadows Park, the ride suffered technical problems, with riders suspended for up to five hours. Even a wedding took place in 1940 among the wires. The wedding photographers and musicians stayed suspended, while the bride and groom went into free fall.

At the end of the two-year fair, the Tilyou family purchased the ride for $150,000 and moved it to Steeplechase in 1942. Robert Moses, the parks commissioner, demanded they remove the advertisements. While popular, the ride was costly to operate, requiring three attendants for each chute. The ride appeared as a star in the film *The Little Fugitive* (1953) as actor Richie

Andrusco flew to the top of the ride. Only a slight, cloth safety belt encircled his waist as his feet dangled.

Patrons who sat on the slippery, shiny, silver seats could be terrified. Women removed their shoes so the operators below weren't bombarded. Only the free fall at the top paralyzed riders more than the Cyclone's first dip.

Steeplechase Park closed and was razed after the 1964 season, but the Parachute Jump continued to operate until 1968. The ride was abandoned and unclaimed until 1971, when the Parks Department put it up for sale, but Matt Kennedy and the Coney Island Chamber of Commerce requested a landmarks designation. Eventually, the commission declared it a landmark in 1977, but the city council reversed that decision.

Since the cost of demolition rose to $25,000 in 1982, a survey found that the structure was sound, but set its rehabilitation at $500,000 because of its deterioration. A reporter noted that standing under the jump was scarier than riding it. In 1988, the former ride was landmarked a second time. This time it stuck.

In 1992, its restoration began, with steel parts replaced, cables removed and a new paint job in the original colors. At the end of the century, the Voudouris brothers, owners of the Wonder Wheel and Dino's amusement park, completed subsequent repairs.

Now plans have been approved for a Parachute Pavilion, and beacon lights have been installed on top of the structure with the assistance of the borough president. Again, ships will mark Coney Island and the "Eiffel Tower of Brooklyn" in its yellow-and-red glory. Anchored outside Keyspan Park, it shines on the Brooklyn Cyclones, as it should.

Perhaps some parachute rider in the future will catch a fly ball as the Cyclones hit it out of Keyspan Park

Astroland's Last Ride?

October 4, 2007

Our grand Coney Island will be metamorphosing at the end of this summer season. Or will it? The promise—or threat—has been wielded numerous times over the past century and a half; at the turn of the twentieth century, it actually materialized in brilliant luminescence. Then, in the 1970s, the dream collapsed just as spectacularly.

Over time, there has been a democratization of the beach, the park threat by Robert Moses, the casino gamble, promised Disney-fication, the Russian takeover, Horace Bullard's Fantasyland, the Sportsplex and, now, the Las Vegas sparkle.

Gravesend-born Joe Sitt and his Thor Equities—which has bought twelve acres including Astroland; Henderson's, a former hotel, bathhouse, music hall and restaurant; Nathan's; and Deno's Wonder Wheel Kiddie Park—have led the most recent spearhead for $100 million. Thor announced construction of a $1.5 billion entertainment district, according to the *New York Times*.

This will be the last season for Astroland, unless....

The future of Deno's Wonder Wheel remains uncertain, unless....

Several open-ended questions center on whether Thor can get a variance to rezone the amusement section for residential construction. In the August 5 issue of the *New York Daily News*, an anonymous city official declared the glitzy residential enclave concept as "dead in the water." Wary legislators expressed concern that Sitt might flip the property once he has the variance. While hotels will be approved, condos and time shares are out. Thor must resubmit an acceptable proposal.

Meanwhile, another developer, Taconic Investment Properties, has acquired property in the west—the western end of Coney Island. So, still another contender may be heard from.

Thor claims it will retain the owners, the Albert family, to continue to manage the Cyclone and selected Astroland rides and the Voudouris

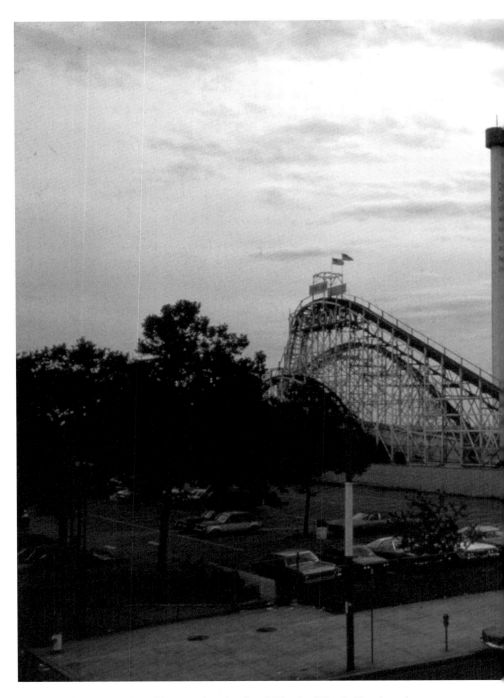

Cyclone roller coaster, AstroTower at Astroland and Wonder Wheel. *Photo by author.*

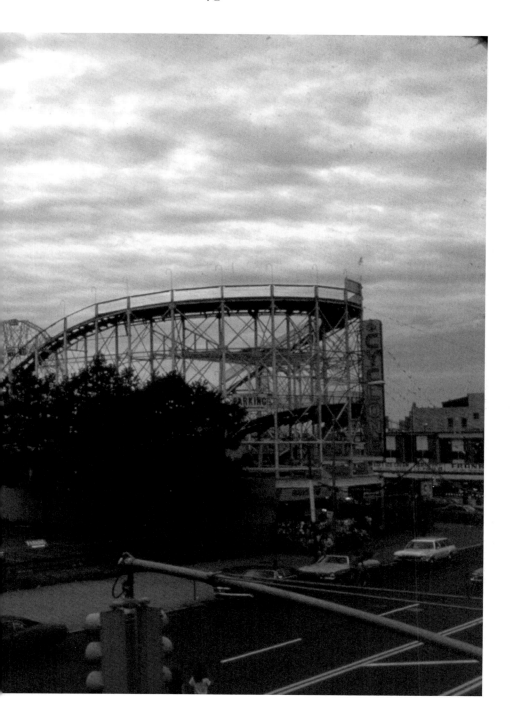

brothers to operate the Wonder Wheel. These two rides are not included in the packages because both are landmarked.

Added to these rides, Thor promises high-tech arcades; a new roller coaster, Coney Island's first since the 1927 Cyclone; and a water park. But can he deliver? Or will he demolish everything, reducing Brooklyn's amusement center to a wasteland of rubble so the city will give in?

Astroland opened on the site of Charles Feltman's nine Teutonic-themed restaurants that began in 1871. Feltman claimed to have introduced the hot dog to American beachgoers. To prevent the property from development and save the "Brooklyn Riviera," a consortium including Dewey Albert, Herman Rapps, Murray Handwerker and others purchased Feltman's restaurants in 1962.

Over the years, they dismantled Feltman's, including the famous 1903 Superba three-decked carousel, which was shipped to Queens for the 1964 New York World's Fair. In a space-themed amusement park, Dewey—who had bought out his partners—installed the Cape Canaveral Satellite Jet ride, a water flume ride, the Mercury Capsule Skyride, the Astroland Restaurant (really a boardwalk food stand), the Astroliner Enterprise and leased Wonderland for the kiddies in 1963.

In 1964, the 270-foot Astrotower, the "bagel in the sky," replaced the carousel. The last Feltman building burned in 1976. In 2000, Astroland promoter Dick Zigun unearthed a time capsule that had been buried under the Astrotower since its 1964 construction.

The Cyclone roller coaster will still act as a barrier between the amusement section and New York City's Aquarium and will continue to be operated by Carol and Jerome Albert and their staff. The eighty-five-foot ride is owned by the City of New York and administered by the Department of Parks. In 1988, the city landmarked it, and it became a National Landmark in 1991.

So it seems that Coney Island may be facing the same quandaries it encountered in the past. Only the city council can predict the outcome, but the mayor has introduced a wild card into negotiations by claiming eminent domain over Coney Island's future.

The Big Wheel

October 11, 2007

E ven though Joe Sitt's Thor Industries has made a deal, the Wonder Wheel, city landmarked in 1989, will continue to spin. And for the foreseeable future, the Voudouris brothers—Dennis and Steve—will continue to operate the Big Wheel. The attraction abuts Astroland, the other Thor purchase.

The 150-foot ride, built in 1920 by Charles Herman and the Eccentric Ferris Wheel Company, has twenty-four cars, sixteen (the red ones) of which swing, with 6 passengers to a car for a total of 144 riders. Sold to

Wonder Wheel and AstroTower at night. *Photo by author.*

Herman Garms shortly after completion, the Wonder Wheel continued to be operated by Herman's son, Fred, from 1935 to 1963. The biggest ride day was July 4, 1947, when 14,506 riders took the chance.

In 1963, the attraction was purchased by Deno Voudouris, a Greek immigrant, merchant mariner and hot dog vendor. After acquiring the central attraction, Deno built other rides around it and over the old Eureka bathhouse that used to stand there. In 1983, Freddie Garms sold Voudouris his last property, the Spook-a-Rama ride. After Deno's death, his sons took over the operation of the attraction.

By 1986, additional property from a nearby fire came on the market for a new kiddie park. Most of this new land was leased, which is how Thor entered the lives of the Voudouris brothers. To attract crowds to Coney Island, Dennis and Steve Voudouris reintroduced Coney Island Air Shows in 1996 and, more recently, with the cooperation of other Coney Island owners, fireworks exhibitions.

While their real estate may be reduced over the next few years as a result of Thor's acquisitions, Dennis, Steve and D.G., a new family face, will be around the boardwalk to make sure the Big Wheel remains in good mechanical shape and keeps spinning.

Catastrophes
from the Past

October 6, 2005

When Hurricanes Katrina and Rita struck, we saw their violence in all its cruel glory right in our living rooms. In fact, most of us knew in advance how vicious the storms would be through charts and maps and simulated images, while only a few expected them to be just another summer shower. What warnings did people receive a century ago? How could they grasp the brutality of nature back then?

Newspapers publishing ever-extra editions became the most prevalent source for information. But journalistic photography was not perfected until the 1890s, so artists added pictures to the word. Obviously, these attempts never had the immediacy we experience with photography, on television and in films.

However, creative minds learned how to reconstruct the experiences. The world's fairs that appeared internationally introduced the most recent scientific advances. Re-creations of recent and infamous disasters appeared in the entertainment sections of these fairs. Then, after the fair was over, these attractions gravitated to amusement parks.

Coney Island, because of its international fame, may have been the most prolific exhibitor of disaster reenactments and related exhibits. Along Surf Avenue, the most renowned disasters played to sellout crowds.

The most popular opened in 1902 in a sturdy auditorium at Surf Avenue and West Seventeenth Street as a depiction of the Galveston flood. These exhibits featured a lecturer to set the scene and prod the imagination. The Galveston, Texas, flood of September 8, 1900, stemmed from a hurricane, despite warnings. With winds over 130 miles per hour, a fifteen-foot tidal wave swept in from the Gulf of Mexico and over the town, resulting in more than 8,000 deaths in Galveston out of a population of 37,700. Property losses totaled more than $20 million, with more than 3,500 homes destroyed. Since then, a seventeen-foot sea wall has protected the shoreline.

In the Coney Island exhibit, the lecturer described the model of Galveston as a sleepy Southern town, where boats ply the water in the foreground. Then, as night falls, clouds close in, winds howl and the storm strikes with a combination of real and painted scenes of water. Simulated lightning flashes, fans blow up the wind and buckets of water sweep the buildings away with the help of mechanical arms as screams from actors rent the air. With the dawn, patrons observed a ruined city. So successful and frightening was the Galveston flood show that a copy of it opened in 1904 at the tribute to the Louisiana Purchase, the St. Louis Exposition. Admission was twenty-five cents.

The Johnstown flood gathered equal attention based on the flood of May 31, 1889, that washed away Johnstown, Pennsylvania, on the banks of the Little Conemaugh River near Pittsburgh. Days of heavy downpour of more than eight inches weakened the South Fork Dam fourteen miles above Johnstown. As with New Orleans, officials knew the dam was crumbling, but telephone and telegraph lines were down. When the dam burst at 4:07 p.m., 20 million gallons sent a seventy-foot wall of water toward the city. Even though the water took an hour to reach Johnstown, no warning reached the citizens. As the deluge approached, it swept the entire countryside with it. People, animals, houses, bridges, schools, steel mills, every tree and even thirty steam locomotives and their tracks came thundering down the valley on the city, causing a ten-minute whirlpool at its center. The result was twenty-two hundred dead, over a thousand missing and days of looting.

A third popular disaster production was based on the volcanic eruption of Mount Pelee at the Caribbean island of Martinique on May 8, 1902. Again, there was warning. The active volcano above the city of St. Pierre had begun acting up on April 23, but no one cared—even though the disturbed earth caused insects and snakes to attack people. The officials didn't want to scare the tourist business. Then, at 7:52 a.m. on May 8, Mount Pelee erupted, spewing hot, sulfurous gases, lava and steam registering nineteen hundred degrees. A black cloud covered over fifty miles, and a resultant tsunami destroyed twenty ships in the harbor. Of the twenty-eight thousand people in the city, only two survived. The city burned for days. Crowds at Coney Island loved it.

The twelve-hundred-seat auditorium was called a cyclorama, in which the audience sat in the center. The building had eleven fire exits because of the inside fireworks display.

Dreamland, which would be engulfed in flames in 1911, recreated the San Francisco earthquake. The exhibit was divided into three parts: the history of gold and expansion in California, views of the city before the fire and the ultimate destruction.

The earthquake began at 5:13 a.m. on April 18, 1906. At least fifty fires ignited wooden buildings immediately. But with the water mains burst, the fire raged unchecked. To control the spread, firemen dynamited a ditch one mile long and 175 feet wide. Nevertheless, fires continued for two more days, destroying 28,188 buildings on 512 blocks, worth $299 million in insurance claims. The human cost: five hundred crushed or burned to death and three hundred missing.

So popular were these disaster productions that the hotels at Manhattan and Brighton Beaches adapted them and the accompanying fireworks as well. They staged the Fall of Pompeii, in which visitors sitting in a Greek temple watched Mount Vesuvius destroy the city—with a little help from electricity. The Battle of Vera Cruz was refought, a reenactment of the Boer War was led by veterans from the original, the fall of Adrianople with the Turks fighting Greeks, Bulgarians and Serbs was re-created and the naval battle at Vladivostok raged again.

The Great Naval Spectatorium in 1904 featured the War of the Worlds, in which an audience sitting in a makeshift gun battery that guarded New York watched as the navies of Britain, Germany, France and Spain attacked us. The American navy sank them all. This exhibit showed a bit more sophistication, with actors and acrobats performing in front of a canvas Statue of Liberty.

Later, popular taste turned to the Fall of Port Arthur in the Russo-Japanese War; the Great Shipwreck, an attack on Delaware by the brother of Captain Kidd; and the Civil War battle between the *Monitor* and the *Merrimac*. Less violent fantasies revolved around trips to the moon, to Mars by "aeroplane," by submarine to the North Pole and a journey to Little America at the South Pole in front of an animated canvas with electric effects, natives and dog sleds.

Daily performances of horse-drawn fire engines careening around corners to extinguish fires in multistoried buildings at Dreamland and Luna Park attracted hordes. As firemen poured water on the façade, acrobats leaped from upper-story windows. The exhibits continued until both parks themselves went up in flames.

Saving Coney Island

February 24, 2003

Coney Island has always been ephemeral. It was conceived as a dream, as in Dreamland. Buildings made of wood and lathe never promised much of a future. So, with regularity it burned and was washed out to sea or demolished in the night. But over time, the imagination that conceived the rides, the architecture and the designs disappeared. The wealth of ideas vanished into the sand dunes.

Now an attempt is being made to stop the erosion of time. The New York City Landmarks Commission has recognized another relic of history: Childs' Restaurant on the boardwalk. Built in 1923 to add attraction to the newly completed boardwalk, it represented glamour to many who dined and danced there in the giddy 1920s and lean 1930s. This was not the first Childs' in Coney Island, but it was the first on the boardwalk, where diners could gaze out over the waves.

An earlier Childs' had been on Surf Avenue and West Twelfth Street, now Dick Zigun's "Sideshows By the Seashore." The Childs' chain represented a cheap, clean alternative for middle-class diners. It was not quite the Automat but, like the Schrafft's Restaurant chain, the cafeteria became a predecessor of the fast-food eatery. But only Childs' had dancing.

The free-standing rectangular building reflects Spanish colonial architectural influences, with numerous maritime motifs decorating the roofline and windows. Created in terra cotta, the building stands as one of the few remaining symbols of Coney Island's heyday.

Said Landmarks Chairman Robert B. Tierney:

> *The former Childs Restaurant building is a wonderful reminder of the days when Coney Island was considered "the world's largest playground." The building's whimsical architecture, which survives as a celebration of the area's past, is now secured for the future.*

Childs' Restaurant on the boardwalk, 1930. *Photo by Irving Underhill. Brooklyn Public Library, Brooklyn Collection.*

According to the *New York Times*, the Landmarks Commission recognized the architectural features as well as "the social history the building evokes."

Since it is adjacent to Keyspan Park, where the Cyclones play baseball in the summer, the building—which had housed a chocolate factory until recently—could be used as a restaurant again or a catering hall. Founded by brothers Samuel and William Childs at the turn of the twentieth century, Childs' Restaurants prevailed in New York until the 1970s, when they were bought by the Riese brothers.

Landmarks have been named in Coney Island before, but the politics are complex and the designation elusive. While the Cyclone, the Wonder Wheel and the Parachute Jump—now being refurbished—have all been designated landmarks, the Riegelmann Boardwalk could never be considered because of the constant replacement of the wooden slats.

Several bathhouses still survive in other uses, but Stauch's on Stillwell Avenue off the boardwalk fell to a demolition company over a weekend. While preservation efforts to save the Thunderbolt proceeded, Mayor Rudy Giuliani ordered it torn down on a Friday night to cleanse the sightlines from Keyspan Park. The Tornado and numerous carousels disappeared before preservation laws were enacted.

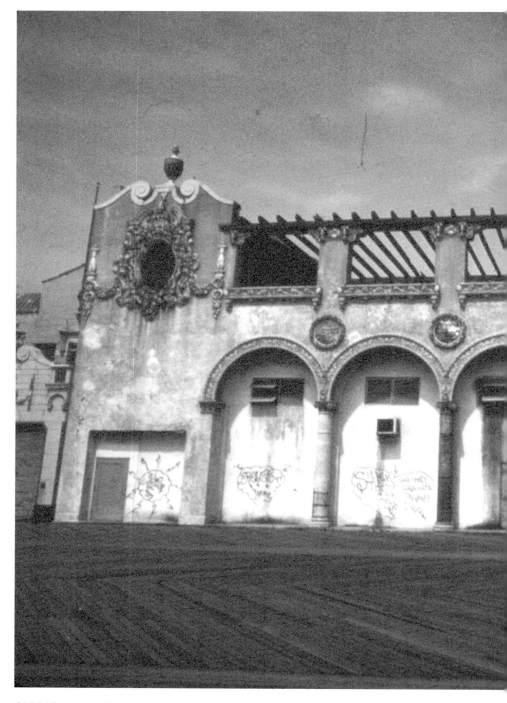

Childs' Restaurant before it was landmarked. *Photo by author.*

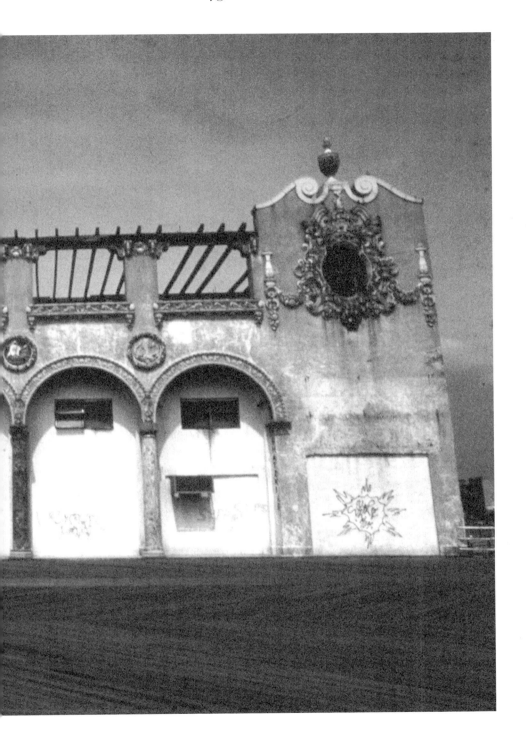

Earlier, Dreamland and Luna Park had burned, and Fred Trump—Donald's father—tore down Steeplechase. He even tried to remove the Parachute Jump, but demolition costs precluded that. The famous Half Moon Hotel succumbed to time and almost self-destructed.

Many world's fairs had contributed to the décor and design of Coney Island, with rides from the Philadelphia, Chicago, Buffalo, St. Louis and New York expositions. Since the fairs, too, vanished in a short time, the amusement park held the only memories of these tributes to progress.

Preservation of Coney Island—in a part of Brooklyn considered too remote, too unimportant, too distant from Manhattan to be of any lasting value—had always been elusive. Then, the Landmarks Commission began to find more historic houses in Brooklyn than in the other boroughs. Soon, Lundy's in Sheepshead Bay was landmarked. The Cyclone, once threatened with demolition, was preserved as well.

At this point, now that Childs' is earmarked for posterity, not much remains to be saved in Coney Island except the sands. Perhaps someday defunct amusement rides from all over the country could be huddled together in Coney Island for a final preservation and stand as a tribute to the Brooklyn seaside's glorious past.

PART IV

Our Protectors

Brooklyn's Guardians

October 26 & November 9, 2006

Back in 1887, when Brooklyn still called itself a city, William Fales, a police buff, wrote a history of Brooklyn's police force that he titled Brooklyn's Guardians. *From its pages and from articles in the* Brooklyn Standard Union *and the* Police Gazette, *I have extracted a mini-history on early crime fighting in Brooklyn.*

Dutch settlers in Brooklyn and New Amsterdam across the river had little concern about crime; only the wild animals committed unlawful acts. However, the danger of fire and annoyance of drunken behavior caused the Dutch burghers to set up a "rattle watch" similar to that in Europe. These civil servants volunteered as night patrol, armed with lanterns, weapons and loud rattles to awaken citizens to an emergency. Essentially, their duties combined those of fire- and policemen.

In time, the watchmen became constables and could be identified by their star-shaped copper badges stamped with the seal of the municipality. From this insignia came the term "star police" and, later, the slang word "copper."

Along with the creation of a constabulary, the Dutch attached a court system in 1646 with the naming of magistrates (*schepens*) and district attorneys (*schout*) to deal with crimes of river piracy, stealing of fences and taxation. Jails were not needed, for offenders were punished publicly in the stocks and kept in a "pound."

It was up to the English to establish courts, the first in Gravesend (1668) and the second in Flatbush (1692). Early constables were appointed annually at an eighteen-dollar salary as the need arose, but they did not join together as a force; private guards supplemented the duties of the watches.

Finally, in 1802, the communities saw a need for a jail, known as a "watch house" or a "calaboose," but security wasn't a priority. The first prisoner pulled out the windows, kicked through the wall and went home. At a

meeting in 1815, the Brooklyn fundamentalists addressed a new problem: vice, namely the increasing violation of working, traveling, playing or selling on the Sabbath.

But a decade later, the Village of Brooklyn had grown so rapidly with new streets and a municipal court that it increased the village watch to twenty-four-hour service and built a sturdier jail at James and York Streets. In 1834, Brooklyn emerged as a full-service city, with George Hall as its first mayor. Two years later, the cornerstone for a new city hall was laid and a new "lockup" opened in Fort Greene on Raymond Street. The new city still did not have an official police force, but it appointed its first captain, John Folk; five city marshals; and built a new court at Cranberry and Henry Streets.

Closing in on the mid-century, problems affecting the City of Brooklyn grew at the same rate as those in the metropolis across the river. While Brooklyn founded the board of education and the *Brooklyn Daily Eagle* started publishing with Walt Whitman as editor, riots between "Nativists" and Irish immigrants broke out on Dean, Court and Wyckoff Streets. These civil disturbances followed similar unrest in New York's Five Points and the Bowery.

So, in 1849, the city watch (still not police) moved into the still-unfinished city hall cellar with a new courtroom on the third floor. Two cells in the basement housed prisoners awaiting court hearings, but steps had not been built to the ground floor. Prisoners had to climb a ladder to be escorted to the courtroom.

Finally, in 1850, New York's state legislature passed an act establishing the municipal police for the cities of New York and Brooklyn. Both followed similar organizational plans, with precincts for each city. In Brooklyn, the First Precinct was Brooklyn Heights and the Second Precinct was its downtown, with a station house at Adams and Myrtle Streets. Under a policy called Home Rule, police appointees selected by politicians served one to two years.

According to the *Brooklyn Union*:

> *The newly elected Alderman* [ward boss] *would pick out certain political favorites who had materially aided him in his elevation as one of the City Fathers, and present them to the Mayor, who would smile graciously, affix his signature to a formidable certificate and the appointee at once assumed the position as a guardian of the peace.*

Needless to say, the resulting corruption spread through both cities, with citizens of the party who were not in power unable to receive justice from the police or the courts.

In 1857, the Albany legislature had second thoughts about the corruption the Home Rule fostered and it created a metropolitan police force for Brooklyn, New York and Westchester County, hoping to solve the inequities. This second law was defied by Mayor Fernando Wood of New York. He retained his municipal police, while the state brought in the metropolitans. Both forces fought each other more than they fought criminals. Finally, the Civil War, the draft riots and Wood's acquiescence solved New York's dilemma.

Brooklyn obediently followed the new law, thereby escaping the conflict, and moved their new police headquarters to Court and Livingston Streets. But it took until 1870 before the state legislature divorced the Brooklyn police from following the patterns set by New York. In that year, Brooklyn created an independent board of the metropolitan police and the city moved forward.

In 1875, a detective bureau was established to cope with the rise in thefts and murders, with ten officers named to the new mounted squad. The board of health created an ambulance service (1878) that worked with the police, and the castle-like Raymond Street Jail housing 682 inmates coupled with the city morgue and opened on Raymond Street (now Ashland Place) and DeKalb Avenue.

A policeman's job is never done, wrote Gilbert and Sullivan. This was most true in Brooklyn, for the police not only fought crime, but also had the responsibility for licensing, inspecting and—until the formation of the Sanitation Department—keeping the streets of Brooklyn clean between 1872 and 1881.

Independent towns outside the City of Brooklyn hired their own police. The last two independent villages in Kings County were Gravesend and Flatlands. Gravesend's political boss, "Chief" John Y. McKane, began as one of the town's two constables. By the 1880s, his power entrenched him as the chief of police (added to a dozen other political titles). He hired his own summertime Coney Island patrol and paid them personally. Many of his part-time police had prison records and were wanted elsewhere. There was a reason why "Boss" William Tweed sought refuge in Coney Island after he escaped from Manhattan's Ludlow Prison.

At the same time, Bob Pinkerton served as a Brooklyn detective and, in 1881, arrested the infamous Red Leary, a notorious bank robber, after Leary's highly publicized escape from the same Ludlow Prison. Leary's wife, also with a criminal record, lived and worked at her Coney Island hotel until she died.

While McKane was never arrested for armed robbery, he manipulated voting records in Gravesend elections and affected at least two national

election outcomes. In 1894, the "Chief" was tried for election fraud and served five years in Sing Sing.

Meanwhile, in 1885, the Harbor Police, a "steamboat squad," attacked river crime, particularly the Red Hook Gang and the Canallers, who worked East River, Coney Island Creek and Gowanus Canal shipping.

As Brooklyn achieved balance, it established a police pension fund, and the annual police parade marched along Bedford Avenue in 1887. Police matrons were hired the same year, and both Moses Cobb and John Lee, the first African American Brooklyn policemen, were hired in 1892.

I would like to think that the 1884 state-mandated Lexow Committee investigation into police corruption in Manhattan left Brooklyn a better and safer city. Then, in 1895, Theodore Roosevelt became New York's police commissioner. But it was a moot point, for by 1898, it was all over for the City of Brooklyn.

Gravesend had been annexed in 1894 and Flatlands in 1896. For those last two years, we were all together. Then, two years later, Brooklyn was consolidated into Greater New York by the state, reduced to a borough and "Brooklyn's Guardians" merged into the New York City Police Department, "New York's Finest."

Brooklyn Cells

June 23, 2005

The term "cell" here refers to prison cells, not cellular phones. Brooklyn has long been called "the city of cemeteries" by those who live in Manhattan, but historians might consider the Brooklyn prison history as well. American rebel prisoners were shipped to Brooklyn as the British shipped other prisoners to Australia.

But all of that is in our past. We have an empty but refurbished prison languishing on Atlantic Avenue, seeking residents. We just don't have enough criminals anymore. It is not like the days of Mayor Ed Koch, when he had to import prison barges to house miscreants. But those barges hark back to the days of our earliest prisons, the twenty-four de-masted hulks moored in Wallabout Harbor, filled with rebels captured in the Battle of Brooklyn.

But incarcerations were nothing new in Brooklyn. In 1686, the Town of Flatbush built a courthouse with the county jail in the basement. The building was enlarged and improved in 1758 by adding two grated windows. British justice proved to be severe.

After the Revolution, the Flatbush Jail was rebuilt and expanded a third time with a cupola added. Public gatherings and town meetings took place in the courtroom. But in 1832, it burned to the ground.

Another Brooklyn jail was not constructed until 1836, when the Raymond Street Jail for male prisoners opened in Fort Greene on Raymond and DeKalb Streets. (Raymond Street has been de-mapped and is now an extension of Ashland Place.) A women's annex was added in 1839. Together they were known as the Brooklyn City Jail and operated under the jurisdiction of the sheriff of Kings County.

Another jail grew in the Crow Hill or Crown Heights section of Brooklyn, where other county buildings languished. Today, only Kings County Hospital remains. Known officially as the Kings County Penitentiary, the popular name was Crow Hill Penitentiary.

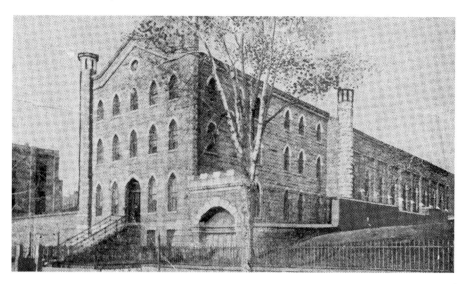

Raymond Street Jail. *Brooklyn Public Library, Brooklyn Collection.*

This prison, located between Rogers and Nostrand Avenues and Carroll (now Crown) and Montgomery Streets, opened in 1848. It existed on the site until 1907. After demolition of the prison, Brooklyn Prep and College, a Jesuit higher education facility, opened there. In 1972, Brooklyn Prep closed and sold the land to City University of New York for Medgar Evers College.

Most prisons of the time resembled medieval fortresses, complete with turrets and towers. Treatment in the prisons included corporeal punishment, hard labor and deprivation of food. Overcrowding of cells created a cesspool of vice and was a breeder of crime.

Civic officials and newspaper editorials demanded reform and more humane conditions. On July 20, 1963, the Raymond Street Jail was evacuated and its prisoners transferred to the new Brooklyn House of Detention on Atlantic Avenue and Jay Street that had opened in the 1950s.

Until the 1990s, the prison served as confinement for Brooklyn's criminal element. Closed for renovation, the prison population at the House of Detention was moved to an unused brig formerly belonging to the Brooklyn Navy Yard.

Now, with city crime diminishing, Brooklyn no longer seems to need jails. The five-year renovation is almost complete, and city hall is now pressing for a grand reopening of the Brooklyn House of Detention, with or without prisoners.

Condominiums and boutique shops, anybody?

It seems almost utopian to have a community of over two million people and no jails, but for the time being the impossible may really have happened in a paradise named Brooklyn.

A Hot Time in Old Brooklyn Town

October 19, 2006

Fire has always been both a boon and a danger. We still fear forest fires and buildings burning out of control. The cities of London and Chicago were consumed by fire, and fire turned out to be the deadliest component of San Francisco's 1906 earthquake.

In 1876, the Brooklyn Theater fire killed 295 people. All three of Coney Island's amusement parks were destroyed by fire, with only Steeplechase rebuilt after its 1907 fire. The dome of Brooklyn City Hall burned; the original Brooklyn Academy of Music on Montague Street burned; the Margaret Hotel burned. Most recently, fire gutted the abandoned Greenpoint Terminal Market.

And to prevent and fight these fires, Brooklyn created a fire department. Actually, fire insurance companies employed early firefighters to prevent paying settlements. If your house was not insured—as indicated by large metal fire plaques affixed to the outside wall—the volunteer firefighters would let it burn. Since most buildings were made of wood, this happened often.

When the first settlers populated Brooklyn, no firefighters existed. Neighbors put out dangerous fires to prevent their own houses from burning. A new schoolmaster appointed in 1661 found that his duties included being a bell ringer to sound the alarm in an emergency such as fire.

The first official Brooklyn firemen were appointed in 1768, the first fire company was chartered in 1772 and the first fire engine went into service in 1785. In 1768, about 300 people lived in Brooklyn. By 1790, when the first census was taken, the Village of Brooklyn (Brooklyn Heights today) had a population of 1,603, so there was a need for a more organized fire brigade.

In a meeting held on April 7, 1772, Brooklyn citizens chose six firemen for a period of one year to protect pre-Revolutionary Brooklyn. This had been spurred by an act of the legislature "for the more effectual extinguishment

of fires near the Ferry…in Kings County, passed the 31st day of December, 1768." Among the appointed firemen were the names John Middagh and William Boerum.

Firemen earned no salary because the annual competition for the position was considered an honor. However, exemptions from jury duty, inquests and the militia rewarded them for their service. The village raised funds for the department equipment through taxation. Responsibility for the care and maintenance of the equipment rested on the shoulders of the "able and sober" firemen.

But organization of the first fire company did not occur until 1785. At the same meeting held at the "house of entertainment [inn]" of Widow Margaret Moser on Old Fulton Street, the men voted to buy a fire engine made in New York, the price of £150 (British currency was still in use) to be paid through taxation. Previous engines had been imported from England.

The first fire engine, which was pulled by the firemen holding a rope, consisted of a wooden box containing a 180-gallon water tank. At the fire, four men operated a pump action. There was no hose on this engine, but a nozzle could throw a stream up to sixty feet, so the engine needed to be close to the fire. Twenty-four leather buckets on the wagon allowed passersby to help quell the fire. The Brooklyn firemen christened the engine Washington No. 1. The company had an inspection and practice the first Saturday of each month.

The Brooklyn fire district ran from the East River and Joralemon Street, along Fulton Street to Bedford Village (now Bedford-Stuyvesant) and back to the river.

By 1788, the company increased to nine, but now the men had to pay for their licenses. This fee was used to cover the company's expenses, which averaged $240 a year. The following year, chimney inspectors were appointed because many fires started in chimneys. The company—now enlarged to thirty—purchased a new fire engine in 1793, with a new alarm bell mounted on the home of Jacob Remsen at Fulton and Front Streets. By now, five thousand people lived in Brooklyn and three fire engines served them, with an independent hook-and-ladder company formed in 1812.

The men of this company carried their hooks and ladders on their shoulders because they owned no vehicle, but by 1818, when their force increased to thirty, they bought a truck for $150 and built a firehouse for an additional $200.

The first fatality of a fireman resulted in the creation of a widow and orphans fund in 1822. Widows received two tons of coal each winter and eight to sixteen dollars; children received five dollars a month until maturity.

As the fire companies increased, the first parade of the fire department took place on July 4, 1826, sponsored by the Brooklyn Fire Insurance Company.

The fire department of the Eastern District of Brooklyn established volunteer fire companies in Williamsburgh. In 1839, the sheriff sold the fire engines to Abram Meserole to satisfy a judgment against the Village of Williamsburgh. Then Meserole rented them back to the fire department for $150 a year.

As rivalry built up between fire companies—often with pitched battles between them—the need for professional firefighters became apparent. In 1869, a paid Brooklyn Fire Department developed through integration of the best units. With the consolidation of Greater New York in 1898, Brooklyn and Queens companies merged with the Fire Department of New York. In 1913, the city companies reorganized so that each received new numbers throughout the city.

Brooklyn Fire Alarums

February 7, 2008

R ing! Ring! Ring! Goes the bell!" This was a line from an old Pete Seeger children's song. At least, I think it was. If not, it's just the kind of topical song he would sing about a fire alarm. And long ago, the word was spelled funny: "alarum." That was a British spelling, but then they spelled "Brooklyn" as "Brookland."

I have written about the Brooklyn Fire Department before, but this section is about "alarums." The first firemen also served as policemen and garbage collectors. And they were volunteers who sounded "alarums."

Long before Brooklyn, Caesar Augustus, a Roman in 24 BC, created the first known fire brigades—known as watchmen who shouted fire warnings and formed "bucket brigades" to put out fires. The Great Fire of London triggered fire watchmen in 1666, but their employers were the fire insurance companies, who had the most to lose. Only after 1865 was the official London Metropolitan Fire Brigade formed.

In the Western hemisphere, the city of Boston created the first American fire regulations in 1631. By 1648, New Amsterdam formed a cadre of fire wardens. The first fire engines consisted of tubs of water carried on long poles by men or pulled on a wagon. Heavy-duty fire hoses didn't exist until 1672 and that was in the Netherlands. In essence, these guardians also cried alarms, initially warning citizens about a fire before actually putting it out.

Brooklyn didn't have its first volunteer firemen until they were appointed in 1788 and incorporated in 1823. It took until 1898 before they were paid: thirteen engine companies and six ladder companies. In Brooklyn Heights, Engine Company No. 2, the Neptune, at Hicks and Atlantic was organized in 1797.

The watches carried trumpets or a horn-like megaphone to call out warnings. But then Brooklyn grew, and in 1793 Jacob Remsen volunteered to have a bell placed in his house at the corner of Old Fulton and Front Streets. But within the year, Remsen tired of the noise, and the bells of St.

Michael's and St. Thomas's Churches served as fire alarms, according to the *Brooklyn Eagle* files.

The bells warned the community until 1865, moving to Middagh and Henry Streets in 1816 and then to a belfry at Bridge and Sands Streets in 1827. Bells in Brooklyn's city hall sounded alarms after its construction in 1850, but the mayor of Brooklyn recommended that the practice be discontinued in 1894. At that point, the telegraph had been introduced and warned of fire threats.

The superintendent of telegraph supervised these alarms, but they were maintained and tested monthly by a private company using Morse code as a communication with the central office. In 1899, the bells were replaced by 754 fire alarm boxes. A notice on the box informed the user that the key to open the box could be obtained at a local address, usually a store or a house. Dissatisfied with a paucity of alarms in Flatbush, the Taxpayers Association (where are they now?) demanded additional boxes along Ocean Avenue after new houses rose in 1900. Two years later, *Eagle* headlines warned that a violent February storm had damaged half of the fire alarms in the city.

With the introduction of electricity to New York, alarm boxes connected to the central headquarters on Jay Street by wire. By 1896, corner fire alarms were so prevalent that a melodrama, called *The Still Alarm*, played at the Brooklyn Academy of Music for the Brooklyn Fire Department Benefit. The plot revolved around a romantic triangle, blackmail and a villain who cuts the alarm wires in central headquarters and then starts a fire. Props included a fire engine, its horses and a Saint Bernard rescue dog. In the end, the fire chief wins the girl.

Today, we see remnants of the old fire alarm boxes standing empty on street corners. The call boxes—direct telephone contact replaced the telegraph—have been disabled because of false alarms and the necessity of frequent maintenance. Citizens phone in alarms with cell phones. The central dispatch office notifies fire stations through computerized relays. Unlike other cities—in Paris, the *Sapeurs-Pompiers* is a branch of the French army—the Fire Department of New York remains under local control and also operates the Emergency Medical Services ambulances.

The most alarming sound we are aware of today is the air horns used by the fire trucks as they roar down the street.

Brooklyn's Deadliest Fire

March 10, 2003

A recent nightclub fire that claimed nearly one hundred lives in Rhode Island brings to mind a tragedy closer to home, but which occurred more than a hundred years earlier. On December 5, 1876, a fire that started backstage burned an ornate downtown Brooklyn theatre to the ground, taking with it 295 patrons.

The Brooklyn Theatre, an elegant building at 313 Washington Street at Johnson Street—what today would be Cadman Plaza East at Johnson Tech Place, near the General Post Office—boasted upper-class patrons who delighted in seeing stars appear on Brooklyn's first-run stages. The star in this case was Miss Kate Claxton, who performed in the play, *The Two Orphans*, as the blind girl Louise, who triumphed over misfortune. (Director D.W. Griffith made a silent film version, *Orphans of the Storm*, starring sisters Lillian and Dorothy Gish, in 1921.)

More than a thousand spectators crowded into the theatre for the Tuesday night performance. The audience enthusiastically enjoyed the show and the star actress. As the third act reached a conclusion, Claxton looked into the wings and saw a small fire backstage. According to Brooklyn theatre historian Cezar DelValle, she attempted to calm the audience, but the fire quickly spread to the velvet stage curtain.

Panic soon set in, and five hundred patrons in the balcony rushed for the exits. The narrow stairs from the balcony and the five, narrow doorway exits quickly became blocked by bodies. The fire swept out of control, with the entire building engulfed in flames. Within half an hour, the walls and roof collapsed.

Claxton, unhurt but dazed, wandered away, winding up in New York's City Hall Park, not remembering having taken the ferry there. This was not the first theatre that had burned after she had performed in the play—seven theatres had gone up in smoke—so she had good reason to feel jinxed.

More than a hundred of the victims were so badly burned that they could not be identified. Their bodies were moved to a nearby stable, according to DelValle, and then buried in a mass grave in Green-Wood Cemetery.

More than two thousand mourners attended the ceremony of burying the 103 coffins, wrote Jeffrey Richman in *Brooklyn's Green-Wood Cemetery: New York's Buried Treasure* (1998). A circular trench was dug seven feet deep for the common grave. Two hours of speeches and tributes followed a memorial concert given by sixty German singers. A granite obelisk memorial carved with inscriptions marks the site.

Claxton, who died in 1924, is also buried in Green-Wood.

The original fence surrounding the mass grave site disappeared (stolen?), and Ken Taylor, vice-president of operations at Green-Wood, said that a volunteer organization, Saved in Time, still seeks funds to restore damaged sites and ongoing erosion, such as that which has befallen the Brooklyn Theatre Fire Memorial.

The disaster caused both Brooklyn and New York City officials to create stronger safety standards for theatres, with exits clearly marked and kept clear. Ironically, the stable that served as a temporary morgue later became Polk's Theater, which burned down in 1890. Rebuilt as the Hyde and Beaman's Theater and later transformed into the Tivoli, a movie house, according to DelValle, it, too, burned to the ground in 1951.

Only the Chicago Iroquois Theater fire in 1903 exceeded the number of casualties, with 602 dead. In spite of more stringent safety laws, a fire at a social club in the Bronx killed 25 persons in 1973, and 87 people died in the Happy Land Social Club fire in 1990, also in the Bronx.

Within New York City, only the burning of the steamship, *General Slocum*, an excursion ship, claimed more lives, killing 1,021 in 1904.

Other memorable tragic fires include the Triangle Shirtwaist Factory fire of 1911, in which 146 died; a fire in 1941 aboard the SS *Panuco* moored at Pier 27 in Brooklyn, in which 41 persons died; and a Brooklyn Navy Yard fire aboard the aircraft carrier *Constellation* in 1960, in which 50 died.

As of the last count, ninety-six people were confirmed dead in the Rhode Island fire caused by pyrotechnics employed by the '80s heavy metal band, Great White. The fireworks burned the small, wood-framed nightclub to the ground.

Lyrics to the ballad "The Brooklyn Theatre Is Burning," written shortly after the tragedy, go:

> *Hark, do you hear the cry, "Fire"?*
> *How dismal the bells they do sound.*
> *The Brooklyn Theatre is burning,*
> *It's fast burning to the ground.*

PART V

Neighborhoods

Gentrification is Rebirth

April 22, 2002

Gentrification is not a polite word in liberal Brooklyn. It connotes a situation in which the haves impose their lifestyle on the have-nots. Gentrification is an offensive word to many Brooklynites. And yet, most people enjoy and benefit from the result.

Two recent surveys, one in New York City and the other in Boston, support the idea that gentrification is not negative, but rather contributes to the positive development of a community. As reported by the *New York Times*'s John Tierney on March 26, the survey claims that poorer residents ally themselves with their new neighbors and stay to reap the new benefits. So, in reality, the rich don't force the poor out; they cohabitate with them. Gentrification becomes a natural order of progression.

Today, we rise meteorically and fall even faster. Former Brooklynites who return to their childhood neighborhoods are shocked to see changes. Do they remember that many years ago they left to find a better life? As if time could stand still and they could keep their youth.

They are experiencing a natural cycle. Certainly they do not dress or think the way they did twenty, thirty or forty years ago. But if they looked closer at those old neighborhoods, they would see a type of person there similar to them in their youth: a worker, a person striving for success, one who is willing to take chances.

A neighborhood that is fresh begs for young residents, rich or poor. They flock to Bay Ridge or Park Slope or Fort Greene. The new life has energy and excitement, more than the old-fashioned homes of their parents. As they succeed, they move up.

But what happened to their parents' neighborhoods? As earlier generations move into retirement homes or die off, the neighborhoods attract new residents, maybe a different ethnic group, but those who are appreciative of the chance to have a different life. Then, times and fashions change; someone finds a "gem" and invests in it. Realtors notice and prices increase again.

This phenomenon happened in Paris and it happens in Brooklyn. A section in Paris known as Montmartre enjoyed prosperity, but the rich escaped to the more alluring countryside and abandoned the city to its artists. The *artistes* had lived in the narrow streets of Pigalle, below Montmartre, so they appreciated their new view from the top in the shadow of Sacre Couer. Then tourists and patrons of the rich returned to reclaim the warrens of the artists. So the artists moved on to the Marais.

Haussmann, the Robert Moses of Paris, got rid of cheap housing to build his new boulevards, so the artists moved to the Latin Quarter. In the last century, the Lost Generation—Hemingway, Stern, Picasso, Fitzgerald—discovered Paris; the Left Bank became the new home for artists. Always moving, these creative souls lived where they could afford.

And yet, these are the hubs of excitement, of color, of life in the City of Light.

Brooklyn has a population larger than Paris. We have a similar pattern of development. Our neighborhoods have grown, then decayed and were reborn. This is the cycle of renewal in downtown Brooklyn. Atlantic Avenue once boasted a hotel on every block. A train carrying produce from Long Island ran down the middle of the street to South Ferry in Brooklyn Harbor. Then a law declared the train a menace and it was removed—along with the thriving economy.

Its neighbor, Brooklyn Heights, once the home to farms and large estates with merchant landowners, appeared undesirable. Brownstone houses cost too much to heat, clean and maintain. The Brooklyn-Queens Expressway suddenly split Williamsburg, a hearty, thriving neighborhood until the mid-twentieth century. It withered. Bedford and Stuyvesant, two towns symbolic of upper-class white wealth in the early nineteenth century, merged and absorbed Harlem's overloaded population in the next century. Red Hook, a bustling port with lively streets, disintegrated with the industrialized Gowanus Canal below it and the Gowanus Expressway above, resulting in a sudden loss of business and prestige.

These neighborhoods boasted pinnacles of glory, then fell to dissolution. Today, however, they have rebounded—as a result of gentrification. Which would we rather have—a dead city or a live, reinvigorated one?

Even the wilds of Canarsie show new life. Once a port for ferries to the Rockaways in Queens and then an amusement Mecca, it became noted for its clamming, its wetlands and later for its garbage and its smells. Just outside Canarsie, Starrett City mushroomed first, and now an industrial-shopping complex is rising.

Russians brought the former posh resort of Brighton Beach back from fear and oblivion, breathing life into a dying and dangerous community.

Jack the Horse Tavern. *Photo by author.*

Sunset Park has absorbed the aura from its Park Slope neighbor and then transformed itself into an Asian village. The same rebirth has happened in Prospect Heights.

This "evil" spirit of gentrification has introduced Brooklyn to new thoughts, ideas and cultures, making it a comfortable place to live and return to, whether it be Greenpoint or Borough Park or Coney Island. The very fact that new people want to rebuild their lives here makes Brooklyn even more significant—and gentrified.

Brooklyn Heights

Brownstone, Bluestone

March 8, 2007

Brooklyn, more than any other borough, is noted for its Victorian architecture. Streets in northern Brooklyn lined with brownstone and brick row houses, ornate town houses and interspersed with an occasional frame structure or carriage house, reflect the grandeur of that age, transforming those neighborhoods into a nineteenth-century city.

The Brooklyn Heights history harkens back to a settlement of the Canarsee Indians, who established a community there named "Ihpetonga" or "high sandy bank." Then, ten years after landing in Manhattan, early Dutch settlers escaping the chaos of New Amsterdam came across by rowboat and ferry, creating what historian Kenneth Jackson, author of *Crabgrass Frontier* and editor of *The Encyclopedia of New York City*, called "America's first suburb," a residential community on the palisaded bluffs. Beyond its borders was a vast agricultural backyard. The "bucolic atmosphere of Brooklyn Heights" attracted those who wished to avoid the congestion of a city.

Brooklyn developed slowly but with a purpose. Six years after the first steam ferry service, only seven houses dotted the Heights. But developers soon eyed Brooklyn Heights as an investment when the village received a charter in 1816. By 1841, eighty-four heads of household lived there, thirty-nine of whom worked in "the city." By 1860, over six hundred homes had spread through the Heights.

As the years passed, more stalwart structures replaced wooden buildings in the new City of Brooklyn. When land was cheap and plentiful, successful landowners created mansions. But Brooklyn achieved a popularity that made space a premium. The demand made the palatial homes unpractical, so houses with narrow frontage of twenty-five feet and greater depth evolved.

White, Low and Pierrepont mansions (1857) on Montague Street and Pierrepont Place, Brooklyn Heights, circa 1890. *Brooklyn Public Library, Brooklyn Collection.*

The row house—a more substantial variation of the tenement—arose on the streets of Manhattan and then exploded into Brooklyn. It was practical for the builder, who would construct a string of houses on one block, and for the buyer. The brownstone represented stability in a time of social turmoil. The extended inner space of the row house condensed a family's possessions, including the servants, into one building.

The brownstone house developed as a variation of the popular Greek revival design. Brownstone, a reddish-brown sandstone called "Jersey freestone," came from Passaic County, New Jersey. Initially, the stones had been used in the construction of basements. Now, stuccoed over with added turrets and unique designs, brownstones became castles for shipping merchants and other nouveau riche aristocrats.

The brownstone created its own social pattern. Fronted by rectangles of bluestone sidewalks and a high stoop—a term from the Dutch—the building rose to three or four stories. The basement, a few steps down, housed the servants' work area, a half basement/kitchen.

The main house provided social superiority with its raised first floor, as well as more room and light from large Italianate windows and a door transom. While more cramped inside than a mansion, rooms still suggested

This page: Brooklyn brownstones on Remsen Street. *Photos by author.*

spaciousness. Marble fireplaces decorated the parlor. A dumbwaiter moved food and supplies from the basement to a pantry on the first floor.

A wide doorway with sliding pocket doors to seal off a room or open a dining room connected front and rear parlors. Later, bathrooms were added to the rear corners of the house. A secluded garden grew behind the house. Houses on the waterfront used the roofs of warehouses below to grow lawns and flowers.

The second floor would be the family's quarters, while servants lived on the top floor, accessible by a rear stairway. If the brownstone had a fourth floor, additional bedrooms, a library or an office supplemented the other rooms. Behind the houses, carriage houses—such as the mews in Grace Court Alley—added their own charm.

Brownstone neighborhoods prevail in Brooklyn because the city decided not to expand in mid-century, a step not taken by Manhattan. Steam trains, a new form of transportation after the 1830s, scared many Brooklynites with their recklessness, runaway cars, smoke and sparks. So in 1860, the City of Brooklyn banned trains. Produce and material from Long Island needed to be off-loaded from trains onto wagons at Jamaica, prompting shippers to seek alternate, and cheaper, means. As a result, much of Brooklyn Heights and vicinity remained intact into the twentieth century, whereas Manhattan restructured itself.

But in 1908, the subway destroyed Brooklyn's seclusion. Wealthier homeowners moved out, brownstones were subdivided and more hotels arrived: the St. George, Towers, Bossert and Touraine. But despite progress, much of the brownstone aura remains.

The sturdiness and permanence of these structures (as well as the views from the Heights) also attracted celebrities to these northern communities. Thomas Wolfe, Norman Mailer and both Henry and Arthur Miller lived there. Over time, they were joined by Truman Capote, Carson McCullers and W.H. Auden, who occupied the brownstones, frame houses and carriage houses.

When Robert Moses invaded New York neighborhoods, he demolished brownstones through the power of the Housing Act of 1949. Had not the homeowners protested, all of Columbia Heights would have been leveled. Moses's incursion sparked a backlash of preservation reactions that partially resulted in establishment of the Landmarks Preservation Commission in 1965. The first neighborhood landmarked in New York State was Brooklyn Heights. Then the tide turned again, and young, successful couples today remodel their million-dollar homes. Despite the obvious wealth now in Brooklyn Heights, a sense of intimacy surrounds these contemporary gems of realty.

Today, brownstones are scattered throughout landmarked neighborhoods of Brooklyn Heights, Cobble Hill, Park Slope, Clinton Hill, Fort Greene,

Stuyvesant Heights, Boerum Hill and sections of Sunset Park and the former Gowanus, Carroll Gardens. Brooklyn Heights and the adjoining neighborhoods still stand out as an art treasury.

Really Old Brooklyn Heights

October 12, 2006

Last month, I talked about old Brooklyn to a charming audience at the Heights and Hill Community Council on Montague Street. As I looked around the senior group, I realized their recollections of Brooklyn Heights antedated memories and even ages of many newcomers to the neighborhood. But history transcends even their years.

Who knew that the Heights—and even all of Brooklyn—had been a vast forest before the American Revolution? The farms and businesses had to be carved out from the woods. According to *Brooklyn Eagle* files, the occupying British troops systematically required the settlers in Brooklyn to supply them with wood during their seven-year stay after the Battle of Brooklyn. Therefore, many of the trees in Brooklyn and Queens are new growth from the eighteenth century.

While early Dutch and British residents of Brooklyn established businesses, the landscape primarily consisted of large farms. After all, only seven houses had been built in Brooklyn Heights by 1807; another twenty bordered the East River below.

Names of Brooklyn streets reflect the owners of these farms: Wyckoff, Lott, Remsen and Joralemon. The Sands brothers, two of these early farmers, had bought the land of John Rapelje after the Revolution. Rapelje had been a loyalist during the war, so his 160-acre farm was confiscated in 1784 when he escaped to England.

The Sands brothers envisioned a community on Brooklyn Heights, which they named Olympia. However, the idea failed to stir enough interest, partially due to the physical hardship of building on the steep palisade.

They sold part of their property to John Jackson, a shipbuilder, who envisioned a different type of community: he called it Vinegar Hill, named after the last battle of the Irish rebellion of 1798, hoping to lure disheartened Irish immigrants there. Later, it was known as Irish Town. Then, in 1801, Jackson sold forty acres of the waterfront property to the new federal government for a navy yard and farmed the rest.

The property of Hezekiah Pierrepont filled the land between today's Remsen Street and Love Lane. His distillery sat at the foot of Joralemon

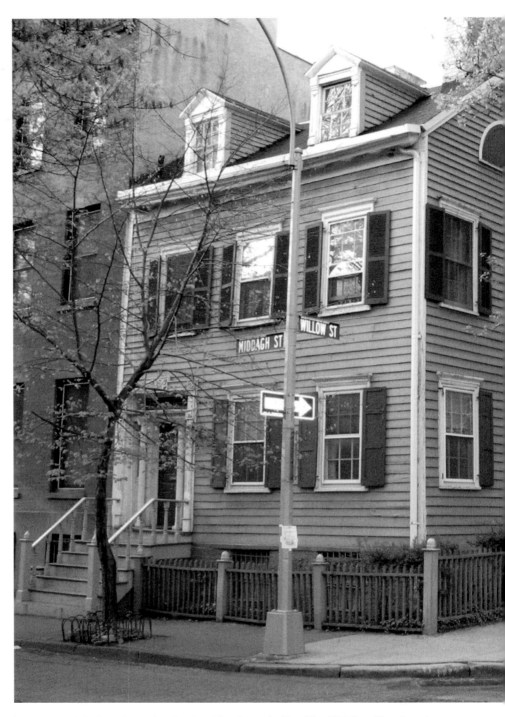

Number 24 Middagh Street (1820), the oldest house in Brooklyn Heights. *Photo by author.*

Street. The Remsen farm lay nearby between today's Remsen and Joralemon Streets, running from the East River to Fulton Street. The Tunis Joralemon dairy farm ran south from there.

But it wasn't long before developers eyed this expanse of property and, just as speculators do today, started buying up farmland. In 1826, Charles Hoyt started building on the Boerum Hill area, and by 1847, Leffert Lefferts became one of the largest real estate holders in Brooklyn.

While even the Heights and Hill seniors would not remember those happenings, the *Eagle* reported on a more recent Brooklyn Heights that would stir nostalgia. In 1947, the newspaper published a series of booklets tracing the history of Brooklyn. The event was the 300th anniversary of Brooklyn celebrated in 1946. The booklets focused on the original Dutch towns of Breuckelen (Brooklyn), Midwout (Flatbush), New Utrecht, New Amersfoort (Flatlands), Boswijck (Bushwick) and Gravesend, the one English town.

At the end of the Brooklyn booklet, a diary catalogued highlights in Brooklyn history, including the renaming of Montague Street from Constable Street. The diarist noted that excursion boats left from Jewell's Wharf next to Fulton Ferry and that Thomas Nast, the famous caricaturist, came from Brooklyn.

The listing of the many Brooklyn hotels and restaurants, however, indicate that Brooklyn was truly a center of social and political life, a strong contender for the position that Manhattan has claimed. Among the great hotels of Brooklyn—most located in or near the Heights—are the block-long St. George and the Towers; the Bossert, with its Marine Roof; the Pierrepont; the Granada in Fort Greene; the Touraine, the Margaret; the Standish Arms; the Montague; and the Clarendon.

Restaurants in and around the Heights and downtown included Michel's in Park Slope, the Brass Rail, Schrafft's, the Park Terrace, Fred Schumm's, the Bank, Silsbe's, Enduro's (now Junior's), Heyman, Foffe's, the Hamilton, the Cordon Rouge, Sonsire's, the Hole in the Wall, Mammy's Pantry, Mimi's, Gage and Tollner's, Ross's, Court Café, Joe's, the Mansion House, Colony Inn on Flatbush Avenue, the Riding and Dining Club and Newkirk Plaza over in Flatbush.

I'm sure several favorites have been omitted, such as the genteel dining rooms in the department stores, but most of those establishments would give Smith Street competition in both quality and price. Only Junior's remains, so drop in and test their hot roast beef.

But now the annual Brooklyn Eats party highlights newer Brooklyn emporiums. We can only hope that their memories linger as long as those of yesteryear.

The Streets of Old Brooklyn Heights

July 12 and July 19, 2007

Brooklyn Heights weaves and wanders atop a palisade, incorporating four hundred years of history. Much of this chronicle can be unearthed from the names of the streets winding from the bay inland.

One of the early settlers, landowners and developers had the area gridded and broken into lots of twenty-five by one hundred feet in 1819. His name was Hezekiah Pierrepont and he promoted Brooklyn Heights as a refuge for the nineteenth-century monied class. Using land that he purchased, he encouraged development of farms, estates and the Village of Brooklyn. Later, he promoted development in other sections of New York State. His son founded Green-Woods Cemetery and the Long Island Historical Society, now the Brooklyn Historical Society. One of the early results of his sales efforts is the oldest house in the Heights at 24 Middagh Street, dating to 1820.

Several other street names can be traced to Pierrepont's influence. Montague Street had originally been named Constable Street after Mrs. Anna Maria Constable Pierrepont. It was renamed after Lady Mary Montagu, a member of the Pierrepont family, an English writer and a feminist who campaigned for inoculations against smallpox.

Columbia Heights with Brooklyn Bridge, circa 1890. *Photo by George Brainerd. Brooklyn Public Library, Brooklyn Collection.*

Elizabeth Place recalled Elizabeth Cornell, who built the original Pierrepont mansion overlooking the Brooklyn Heights bluffs. (It has since been replaced by the Pierrepont Playground.) Hunts Lane was named after John Hunt, who bought land from Pierrepont.

Other families had ties to both Dutch and English ancestry. Among these were the Middaghs, a pre-Revolutionary family who married into the Hicks family. Middagh Street was named by John Middagh to honor his family. Hicks Street was named by John and Jacob Hicks, seventeenth-century brothers who operated a ferry between New York and Brooklyn and owned a large chunk of the Heights. Poplar Street, named for the tree, had been connected to the Hicks estate.

Remsen Street comes from the name Rem Jansen Vanderbeek, a blacksmith who arrived in Brooklyn in 1642 and married Annetje Rapelye in one of the first recorded marriages here. Pierrepont named the street after Henry Remsen, or "the son of Rem."

Another Dutch name is Schermerhorn. The street was named after Peter and Andrew Schermerhorn, successful merchants who owned a 160-acre farm in Gowanus, which they sold in 1835 to Green-Wood Cemetery. Schermerhorn Street originated as a "ropewalk" passageway. The Schermerhorns married into the Astor family.

Livingston Street honored Brooklyn's only signer of the Declaration of Independence, Philip Livingston, who owned a forty-acre estate in the Heights. Garden Place originally had been a section of his country garden. Near Schermerhorn Street is Joralemon Street, named after a saddle maker, Teunis Joralemon, who moved to the Heights in 1803, when he bought a section of the Livingston estate. He vigorously opposed the gridding of streets in the Heights, particularly through his property.

Clinton Street was not named after a former president, although he tried three times for that position. DeWitt Clinton was elected as both mayor of New York City and governor of New York State. He also served as senator and promoted public education, public health and was the driving force behind the construction of the Erie Canal.

Several of the names instrumental in creating Brooklyn Village, the site of Brooklyn Heights and the predecessor of the City of Brooklyn can be found among our streets. Doughty Street honors Charles Doughty, a lawyer who helped create the eighteenth-century settlement. William Furman was a Kings County justice, a friend of DeWitt Clinton and a state legislator. His son, Gabriel Furman, also became a judge, a state senator and the author of an 1824 history on the Town of Brooklyn. Hence, Furman Street.

Old Fulton Street, not to be confused with the one originally named Main Street, connected Brooklyn's Fulton to Manhattan's Fulton. Named

after Robert Fulton, who introduced steam-driven ferries in 1814 with his *Nassau*, it had been gridded in 1704 as Kings Highway.

Adams Street originally had been Congress Street, but Joshua Sands, a landowner in the Vinegar Hill vicinity, had it changed to honor President John Adams, who served as vice-president under George Washington when the capitol was New York. Coincidently, Adams had named Sands as port collector.

To recognize the legal profession that would be crowding the sidewalks in the future centuries, George Street was changed to Court Street in 1835, even though the only nearby courtroom would be inside Brooklyn's City Hall and would not be completed for another fifteen years. Other assorted byways in the Heights have been named after doctors—Henry Street, originally John Street (1816), after Dr. Thomas Henry, a physician and president of the Medical Society of the County of Kings; and Tillary Street after Dr. James Tillary, an eighteenth-century physician who worked on yellow fever. A ship's captain, William Clark, was remembered by Clark Street, where he built a ropewalk in 1806.

Several clergymen are remembered. Cadman Plaza was named for the Reverend Dr. Samuel Parkes Cadman of Brooklyn's Central Congregational Church, and Aitken Place was named for Monsignor Ambrose Aitken in 1960, the priest of St. Charles Borromeo Roman Catholic Church on Sidney Place. That street, originally named Monroe Place until 1835, honored Sir Philip Sidney, a sixteenth-century writer and statesman who died fighting the Spanish while defending the Netherlands. Today's Monroe Place, between Clark and Pierrepont, the widest street in the Heights, was named after James Monroe, the president who died impoverished in New York City in 1831.

Columbia Street had been the 1819 name for three streets: Columbia Heights, Columbia Place and Pierrepont Place.

Then there's Grace Court, named after Grace Church at the corner of Hicks. Across Hicks lies Grace Court Alley, a cul-de-sac of former carriage houses transformed into luxury housing. Everit Street, on the other hand, was named for a butcher. Then there are the "fruit streets," Pineapple, Orange and Cranberry (1821), and both Willow Street (1820s) and Willow Place (1842), which have questionable origins.

For the romantic minded, Love Lane exists because a beautiful maiden, Sarah DeBevoise, lived there and met her suitors by a fence. Around the corner, a short street called College Place remembers a short-lived institution, the Brooklyn Collegiate Institute for Young Ladies, that existed for thirteen years. Its 1829 cornerstone was laid by Marquis de Lafayette. In 1875, the institute reopened as the Mansion House Hotel.

Playgrounds and Parks

The parks and playgrounds of Brooklyn Heights have their own etymology. Most seem to honor long-gone buildings or people.

Squibb Park, now closed, adjourned the massive Squibb factory with a model of the company's logo on the roof. Edward Squibb was a chemist who founded his company in 1856 in anticipation of producing quality drugs. Eventually the company developed anesthesia. When E.R. Squibb merged with Bristol-Meyers, the Brooklyn plant closed, allowing Jehovah's Witnesses to buy and convert the huge factories to their use. The Watchtower replaced the roof logo.

Replacing the Squibb Playground was the Harry Chapin Playground across the street, honoring a popular folksinger, activist and Brooklynite who was killed in an auto accident. Scattered around the playground are symbols of taxis, a reminder of one of his more popular songs. The playground occupies the site of several homes that burned down. Former occupants included a coterie of writers, musicians and artists who lived in the Heights when it was chic, cheap and artsy. Down the hill is a doggy park, appropriately named Hillside Park for an obvious reason.

Grace Court Alley. *Photo by author.*

At the end of Pierrepont Street lies Pierrepont Playground, so named because it was the site for the huge Pierrepont Mansion, which he bought for his bride. Next to the playground is the former home of the Low family, where Brooklyn and New York Mayor Seth Low grew up.

Between the Chapin and Pierrepont Playgrounds on Clark Street, Stirling Park can be found hidden behind a fence and under massive vegetation growth. The park is the site of Fort Stirling, named after the Revolutionary War general, Lord Stirling (William Alexander), the hero of the Battle of Brooklyn. Under the foliage there is a plaque explaining the reason for the park and its history.

The shrubbery and trees along the promenade are maintained by the Parks Department. Secluded in the middle, a stone Thunderbird, the Native American symbol, can be seen, placed there by park employees in the 1970s. In another small park at Montague Street, a tablet indicates the site of General George Washington's headquarters, and another plaque cites the Pierrepont's home, Four Chimneys.

Capote: A House in the Heights

March 23, 2006

With the Academy Award triumph of Philip Seymour Hoffman portraying Truman Garcia Capote, a Brooklyn celebrity has been reincarnated. Albeit, the tinny voice grates on the nerves, but Hoffman accurately duplicated the grating personality of Capote, the writer and journalist.

In the movie, Brooklyn scenes are suggested by long shots of the Brooklyn Bridge and then a scan of brownstone roofs before entering the '50s cocktail party set. It is true that Capote lived in the Heights at 70 Willow Street as an emerging writer and wrote about it in an article for *Holiday* magazine. The article has been expanded with a new introduction and was republished in 2002 as a slim book called *A House on the Heights*. Though it reads fast, Capote's observational and writing skills emerge.

George Plimpton, in the introduction, recalls his first impression of Capote by the magazine editor, John Knowles: "He came in from Brooklyn...this incredible little person in a black velvet suit." The yellow brick house he lived in dated to the 1820s, but it wasn't his. Oliver Smith, the stage designer, owned it, and Capote rented two basement rooms there. However, the house was huge, with twenty-eight rooms and twenty-eight fireplaces, which Capote would show to friends when the owner was away.

While no dates are given either in his text or by the publisher, the time should be the late 1950s, before the 1966 landmarking of the Heights. Among exciting neighborhood events, he cited the arrest of the Russian secret agent, Colonel Rudolf Abel, who operated around Clark Street and was arrested in 1957.

But Capote loved living in Brooklyn, even though this decision confounded his Manhattan confreres. He referred to the Heights as an oasis and opened the article with the sentence: "I live in Brooklyn. By choice." Strolling through the streets, he observed that "traffic is cautious," and he regarded converted carriage houses as "doll-pretty dwellings." His neighbor, Philip Broughton, lived in a 1790 colonial, which he called the oldest house in the Heights. (According to the records, however, the oldest house dates to 1820, when the Heights was gridded.) Obviously, though, he relished his time there.

He enjoyed taking friends to Gage and Tollner and to Joe's, and he referred to a cinema adjoining St. George Alley known as the St. George Playhouse or Pineapple Street Cinema. Living in proximity to famous writers—Hart Crane, Thomas Wolfe and Edmund Wilson—impressed him. He also referred to the Middagh Street house, torn down in World War II, that sheltered a literary commune. Naming the residents—W.H. Auden, Richard Wright, Carson McCullers, Paul and Jane Bowles, Benjamin Britten, Oliver Smith and Gypsy Rose Lee—suggests that he wished he had been a part of the ensemble.

During World War II, Capote claimed the military occupied choice Heights residences. He observed that the "personnel treated [the brownstones] quite as Sherman did those Dixie mansions." As a Southerner originally, he may have considered this a sore point. But he admired the "bright new clientele" attracted to the Heights after the war, although he was wary of an unnamed religious sect that was buying up and transforming much of the real estate for its headquarters.

While the homes, their interiors and the waterfront intrigued him, friends asked what he did in Brooklyn. Among other attributes, Capote wrote, "there is the Esplanade [Promenade] to roller skate upon. (Forbidden: still the brats do it.)"

The article ends with a not-unexpected encounter he had in the Red Hook section. Surrounded by street toughs, he ran to safety in his home up on the Heights.

Perhaps that incident piqued Capote's interest to write his last significant work on the criminal mind, *In Cold Blood*, which came out in 1966, but which has again reached the *New York Times* bestseller list as a result of the movie.

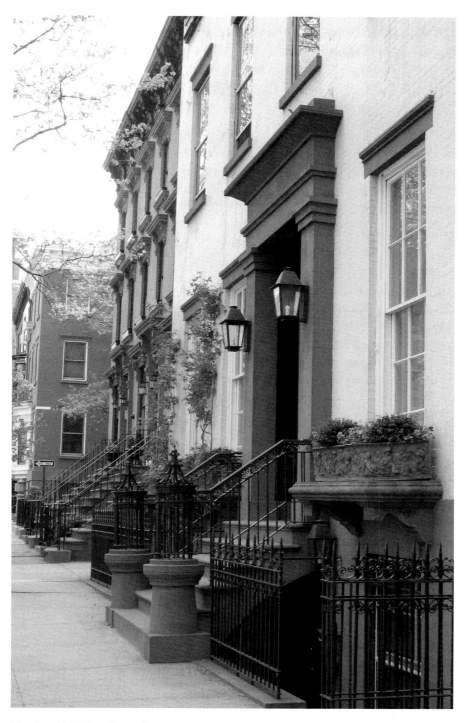

Number 70 Willow Street, Truman Capote's basement home. *Photo by author.*

Brooklyn's Hospitable Hostelry

April 27, 2006

For many years after World War II, finding a decent hotel in Brooklyn proved an impossibility—even the dead avoided it. Now, all that has changed. The Marriott expanded because it boasts an 80 percent occupancy rate. Williamsburg is talking about a new hotel; maybe another in DUMBO. And with excursion ships docking in Red Hook, can a hotel be far behind?

But it wasn't always so. Brooklyn had great hotels where international guests would stay. The largest of them all, with 2,632 rooms—the St. George Hotel, originally built in 1885—occupied a city block and boasted the world's largest saltwater swimming pool. A sign on the building still says "St. George Hotel," but it is outdated. The building is now a residence for Pace students.

Then there's the Bossert. That was a party hotel with big bands, dancing on the roof and its own radio station. Now it is a hotel for Jehovah's Witnesses only, though it has recently been put on the market.

Naturally, New York was a visitors' town, and of the six to seven hundred hotels in Manhattan at the end of the nineteenth century, at least twenty-five were considered fashionable.

The earliest Clover Hill hotel, before the neighborhood was known as Brooklyn Heights, was the Pierrepont House Inn at 55 Pierrepont Street in 1847. The Hotel Bossert replaced Pierrepont House in 1909 and moved to Montague Street. The Mansion House on Hicks Street offered Brooklyn hospitality in 1875 after serving as the Brooklyn Collegiate Institute for Young Ladies in the mid-nineteenth century.

Because transportation was unreliable, hotels sprang up near intersections. Many developed as oversized rooming houses with eight to ten rooms. The Willink House lay on the border leading to the town of Flatbush outside Prospect Park's entrance that still carries the Willink name. In Bay Ridge, the Grand View Hotel dominated the waterfront in the 1890s.

Farther south, Coney Island offered hospitality for those who didn't want to take a two-hour stagecoach ride back to northern Brooklyn. The earliest hotels were the Coney Island House (1824) with the Wyckoff, the Tivoli and the Oceanic built as soon as visitors started arriving with regularity. Only when rail transportation emerged in the 1870s did the larger hotels, romantically called "caravansaries," emerge: the Manhattan in 1877, the Oriental in 1880 and the Hotel Brighton (later Brighton Beach Hotel) in 1878. The primary reason for these more than four-hundred-room lodgings was the attraction of the racetracks and the followers who dined and stayed

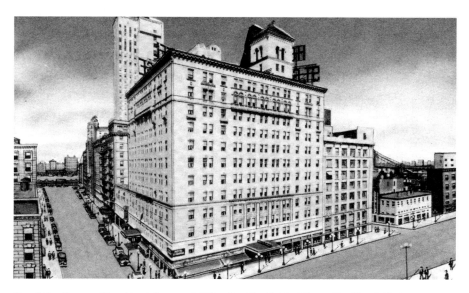

Hotel St. George, Brooklyn's largest, 1920s. *Brooklyn Public Library, Brooklyn Collection.*

Plaques of Miles Standish and the *Mayflower* over the former Standish Arms Hotel, Columbia Heights. *Photo by author.*

overnight to enjoy the weather, the beach and the diverse entertainment at Manhattan and Brighton Beaches.

Smaller hotels for the average "excursionist" dotted the Coney Island shore and main avenues, flowing over to Sheepshead Bay, Gravesend and Canarsie. One of the largest was the Sea Beach Palace at the terminus of the Sea Beach Railroad on Surf Avenue. The last large hotel built there was the Half Moon Hotel, constructed in 1929 on the edge of the 1923 boardwalk. At first it was relatively successful, but during World War II, it became a rehab center for the military. Eventually, its reputation was sealed when it was used to imprison Abe Reles, a witness against Murder, Inc., who "fell" from its sixth-floor window.

Hotels grew in the rest of Brooklyn as well as trees. The St. George expanded with the Towers in 1928 after the subway began a route to the borough. Hotel Palm graced Park Slope. Clay Lancaster's *Old Brooklyn Heights* cites the Montague at 103 Montague Street; Standish Arms at 169 Columbia Heights (soon to be condos); the Star at 66 Hicks Street; the Touraine at 23 Clark Street; and the queen of them all, the Hotel Margaret (1889), at 97 Columbia Heights and Orange Street. The hotel burned in 1980 while being renovated for condo apartments; the space now holds a controversial modernistic residence used by Jehovah's Witnesses.

Among little-known hotels is the Gregory Hotel in Bay Ridge, which has a new life after it was purchased by a chain. In Fort Greene, the Washington Hotel survived into the 1970s as a residential hotel. Borough Park has the Park House Hotel at Twelfth Avenue and Forty-eighth Street. A new Sheraton hotel will open on Duffield Street between Fulton and Willoughby by 2009.

Over the years, perhaps Brooklyn—with its abundance of hotels—has earned the title of "the City of Brotherly Love" more authentically than our southern sister city of Philadelphia.

Tanks a Lot

February 17, 2005

Newcomers who stay in New York long enough are surprised to see police mounted on horses. After all, the army excessed its armored cavalry over half a century ago. Then if the new residents chance to admire the city above its ground floor, they may notice wooden water tanks on roofs of taller buildings. They resemble those tanks that can be seen in western movies when steam locomotives stopped for water before climbing a

mountain. Our newcomers recall that farmers back home still use tanks to water cattle and crops. Ain't New York quaint?

Brooklyn, it seems, has more rooftop tanks than other boroughs because of its age and its older buildings. But they certainly are not an anachronism. In all New York City, over 90 percent of its over six-story buildings have a total of about fifteen thousand tanks. A small residential building would need a tank for seventy-five hundred gallons.

It's all about water. And gravity.

Because the water system in the city dates to the nineteenth century, the aged pipes had a wider gauge. This translated into less water pressure per square inch. City water pressure only reaches five stories. Beyond six stories, buildings use a gravity water feed as a more practical and cheaper source for domestic water in bathrooms and kitchens, and safety water for sprinklers and fire department standpipes. A recent sprinkler law required each building to be equipped with at least two water supplies. The wooden water tanks help fill that requirement.

But why *wooden* tanks? Isn't metal more efficient? But it's more costly. A wooden tank of cedar or redwood costs $25,000; a metal tank costs over $60,000. Wooden tanks are also cheaper to assemble and faster to install. One can be built on a roof in one to three days and it has a twenty-five- to thirty-year lifespan.

The art of coopering, long a trade that most think vanished with the wheelwright and blacksmith, still thrives in the construction of beer kegs, wine casks and water tanks. Durable cedar in two-and-a-half-inch boards is used for the tank walls and floor, and then bound with steel hoops. *Voila*, it's waterproof! No liners, no sealers, no plastic. The wood absorbs the water and seals itself.

The largest wooden water tank company in New York City remains the Rosenwach Tank Company, founded in the 1860s. In 1896, Harris Rosenwach bought out the interest for fifty-five dollars and his great-grandson Andy still runs it from their Long Island City offices. Their Greenpoint offices contain a shop for constructing wooden staves. The Rosenwach Company has built and installed over half the tanks in New York City.

Over one thousand wooden tanks still dot the Brooklyn skyline, according to Andy Rosenwach. The average tank, about thirteen feet in diameter by twelve feet tall, holds ten thousand gallons. Tanks are effective in buildings up to seventy stories. The most recent installation is in a downtown Brooklyn construction site.

After a tank is raised on the roof, only occasional maintenance is necessary because wood is noncorrosive. Usually it needs an annual cleaning. Pumps

in the building basement feed the tank when a float indicates the water level is low. A toilet works the same way. By comparison, a tankless building would need three times the number of pumps working continuously.

Atop the tank, a cone-shaped plywood roof not only prevents snow accumulation, but also houses the float, a switch and an overflow valve. The valve safeguards against electrical malfunction and flooding of penthouses.

So, instead of a relic up there on the roof, wooden water tanks have withstood time and modem invention. And they're all so simple. Recent exhibits on New York City water tanks have been shown at the New York Historical Society and at the South Street Seaport Museum.

StreetScapes: Houses for Workers and Others

August 9, 2007

Joralemon Street has become one of the most traversed thoroughfares in Brooklyn Heights. Named after Teunis Joralemon, a nineteenth-century landowner who bought the land in 1803, the path had served as the southern boundary of the Remsen farm. Ironically, Joralemon fought having streets run through his property. But in 1805, Joralemon Lane connected central Brooklyn to the Pierrepont distillery by the East River below, and the road became well used. By 1842, the lane was transformed into a street.

Today, the street runs from Borough Hall (number 209) to Furman Street, the only Heights through street to the waterfront between Atlantic Avenue and Old Fulton Street. On maps it looks direct, a viable path, but the blocks between Hicks and Furman are steeply sloped and lined with slippery Belgian blocks instead of asphalt. Sidewalks remain attractive bluestones. Still, many pedestrians use Joralemon to access the new Floating Pool this year.

Along the way, visitors can find several interesting and unusual structures after passing the back—but official—entrance to Brooklyn's Greek revival palace: Borough Hall. The block between Court and Clinton Streets remains dominated by the Packer Collegiate Institute, a school since 1854.

The earliest houses on Joralemon were numbers 135 and 139, between Clinton and Henry Streets. Built in 1833, number 135 was slightly burned in a recent fire, but this Federal-style home has been carefully restored so that it stands out as a jewel. A two-and-a-half-story clapboard frame house with twin dormers, it remains unusual for its cast-iron porch and two columns. Phillips Young Ladies School, a private institution, filled number 98 in the nineteenth century. Passing Garden Place, look above the first-

story windows on the corner of 90 Joralemon Street. Carved into the brick is a former name: Garden *Street*.

Proceeding toward the water, Joralemon offers more intrigue after crossing Hicks. The brownstone at number 58 between Hicks and Willow Place built in 1847 just pretends to be a brownstone. Actually, it was transformed in 1908 into "the world's only Greek Revival subway ventilator," according to the *AIA Guide to New York City*. Its purpose is to allow release of air pressure from the Lexington Avenue subway tunnel that runs beneath the building. It can also be utilized as an emergency escape exit.

Toward the bottom of the hill stands what remain of the Riverside Houses at Columbia Place. Built in 1890 by Alfred T. White, the building contains apartments sold to workers for a reasonable price; affordable housing, you might say. The building once extended to Furman Street, but was abbreviated by construction of the Brooklyn-Queens Expressway (BQE) overhead. White had also commissioned similar structures in Cobble Hill.

Finally, at 25 Joralemon Street, a one-story utilitarian building with the words "Main Pumping Station" cut into its granite rests against the BQE supports. Now condos, it served as a pumping station to increase water pressure for fighting fires in taller buildings.

Turn right on Furman and you're at the beach.

These are just a few of the singular buildings and streetscapes found in historic Brooklyn Heights.

StreetScapes: The Old Penny Bridge

April 3, 2008

"Penny Bridge" is a romantic nom de plume for a stone bridge that connected Montague Terrace to Pierrepont Place from 1855 until its demolition in 1950 for the Brooklyn-Queens Expressway and a modern replacement called the Promenade. The stone bridge was designed by Minard LeFever (according to the *AIA Guide*) who designed many city churches. (Brooklyn possessed another Penny Bridge since the eighteenth century. That one crossed Newtown Creek. The same Brooklyn-Queens Expressway transformed it into the Kosciuszko Bridge.)

The reason for the bridge was to permit pedestrians, horses and a cable car to reach the waterfront. When the Pierreponts lived on the bluff overlooking the East River, they walked down to boats crossing to Manhattan or to their distillery by the waterside.

At the time, Montague Street dipped down at the middle of the block. Even today, a patch of Montague Street continues to cross Furman Street at the bottom.

StreetScapes: Coal Chutes

January 11, 2007

With the arrival of winter, Brooklyn thinks warm. In today's brownstone Brooklyn, this means firing up the fireplace to supplement the interior oil heat. In yesterday's brownstone Brooklyn, it meant shoveling more coal in the furnace as well as another log in the fireplace.

Coal? What a strange word in our environmentally conscious world. Yet the nineteenth-century energy fuel was not oil but coal. Consider those brownstones, locked together side by side. How did the coal truck deliver fuel to their basements? Why, through a coal chute, of course. A delivery wagon pulled up in front of the house and slid coal down the chute into a coal bin next to the furnace.

And over in Greenpoint, where the black arts thrived, iron foundries created coal chute covers from the mid-1800s until oil heating replaced coal. Coal chutes differ from manhole covers as they are smaller and found in the sidewalk, not the street. Manhole covers are larger so that a workman can fit through and work on the utilities below. Coal chute covers are for the delivery of coal.

At one point, our city attempted to tax the space beneath the city's sidewalk, so many homeowners in brownstone neighborhoods sealed, cemented or removed the covers to avoid being taxed. Major construction or sidewalk repair removed other coal chutes. For one reason or another, inferior modern covers have replaced many originals. However, these iron sidewalk plates remain as much a part of historic landmarked neighborhoods as the houses that stand behind them.

Walking through Brooklyn Heights streets, I found unique designs on Willow, Remsen and Pierrepont Streets and on Columbia Terrace. While this column is about Brooklyn Heights, many of the covers appear in other historic neighborhoods and throughout our city and others. But they are fast disappearing.

Varying designs of these covers create a heritage in itself, for many are original and handcrafted. Names and addresses of the ironworks or utility company become part of a raised design, a safety feature to prevent a slippery surface. Some show signs of annual wear.

Old Penny Bridge at Brooklyn Heights, from Montague and Furman Streets. *Brooklyn Public Library, Brooklyn Collection.*

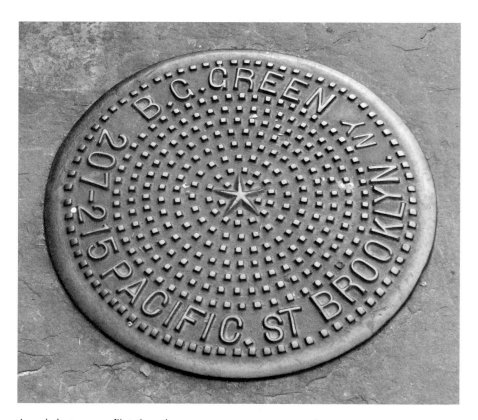

A coal chute cover. *Photo by author.*

Coal chute covers in sidewalk bluestones. *Photo by author.*

Cast iron, poured into molds, became a major industry in Greenpoint and Williamsburg, mostly smaller businesses that employed about thirty-five persons. Several foundries lined Adams Street, and one could be found in the heart of Flatbush. "Coal hole" covers were a small portion of their business, which also designed and produced grates, construction tools, railings and supports for bridges. The names on coal chutes became advertising. One advertised "stove repairs" with an oil conversion pipe next to it.

Among the names discovered in Brooklyn Heights is the firm Howell, Saxtan & Company at 353 Adams Street. Howell had been a mayor of Brooklyn in 1877, and his company worked on the Brooklyn Bridge. Jacob Outwater of 339 Adams Street had been a predecessor to Howell and Saxtan in 1878. Then the companies merged to become Outwater & Saxtan, located at 279 Adams Street.

Other Brooklyn companies appear in our sidewalks, as well as companies from less distinctive boroughs. Bryan G. Green's foundry was on Pacific Street, with several addresses from 207 to 229. A "B.G. Green" coal chute is located near 31 Grace Court, with another at 78 Henry Street. Fox and Gorman of Flatbush Avenue built a coal chute for 39 Remsen Street, and William Taylor of Adams Street has one at 92 Remsen. The Hafker Iron Works, an 1896 firm located at 71 North Portland Avenue in Fort Greene, has a marker at 100 Pierrepont Street.

These companies manufactured other street sculptures: manhole covers, vault covers and identifying logos.

StreetScapes: Other Street Scenery

January 18, 2007

Coal chutes found in the sidewalks of brownstone Brooklyn are only one segment of Brooklyn's underground empire. Beneath our city, a warren of tunnels supplies our essential services. In colonial days, water ran through open aqueducts. But in 1837, recurring health problems caused Brooklyn to build a water tunnel to carry water in from the Croton Reservoir upstate. The Brooklyn Department of City Works (BCW) is still named on a manhole cover from 1855, with which the Nassau Water Company supplied water to Brooklyn, at Remsen Street and Montague Terrace. In Boerum Hill, an 1883 cover reads "Catskill Water Manhole." And BWC represents the Brooklyn Water Commission on an 1887 manhole at Henry Street and Hunts Lane.

After water pipes were buried, other utilities followed. New York and Brooklyn started a concerted effort to remove overhead wires from the streets after many utility poles fell during storms. In 1885, new laws demanded that utilities be strung along a "subway" under city streets. Electric, gas and telegraph companies also ran wires underground, identified today by initials on manhole covers.

The Flatbush Gas Company, with John Lott as president, used "F Gas Co" as a logo in 1864. Their two nineteenth-century foundries were at Douglass Street and in Flatbush at Johnson Street near Snyder Avenue. Among Williamsburg foundries was GAS Pitz, an 1894 company on Scholes Street.

With the arrival of electricity to illuminate homes, electric companies added their wires underneath the city: CEI (Citizens Electric Illuminating Company) in 1883; MEL (Municipal Electric Light Company) in 1884; EEI (Edison Electric Illuminating Company of Brooklyn) in 1887; and BE (Brooklyn Edison Company) in 1919, before they all grouped as Consolidated Edison.

Access to these utilities was provided through manhole covers, which dotted the newly macadamized streets. In addition to coal chutes and manhole covers, streets contain circular and rectangular covers with opaque glass embedded in them. These are vault covers to allow light into workrooms or storage areas beneath them. Among their manufacturers was the Brooklyn Vault Light Company at 262 Monitor Street in Williamsburg. They also had offices at 481 Driggs Street and North Tenth Street. In the same neighborhood was the Healey Iron Works, which manufactured vaults at North Fourth and Fifth Streets in 1876.

In the nineteenth century, trains ran on the surface or on elevated tracks. The Brooklyn Heights Rail Road ran a cable car along Montague Street and then down to a ferry in 1887. But by the twentieth century, electric trains joined the subterranean city beneath us. The BRT (Brooklyn Rapid Transit) submerged rail lines in 1896. Even today, tracks run beneath Joralemon and Hicks Streets, accessible not from a manhole, but from a brownstone house façade. By 1929, the BMT (Brooklyn-Manhattan Transit) took over from the BRT, and the BQT (Brooklyn-Queens Transit) began.

Soon the space beneath the streets was joined by sewers, labeled as Storm and Sanitary (Coney Island). Official agencies created their own covers: the fire and police departments and the Department of Power (DEP). The Brooklyn Borough president has his own manhole cover (BPB); he controlled utilities until the Board of Estimate was dissolved.

Occasionally, survey markers or markers designating names of cement companies can be discovered. Markers in the sidewalk and street advertised

coined words for cement such as "Castle Bros. Cementine," another familiar name in the Heights. A keystone shape represents Keystone Cement Company of 1373 Broadway. Kerrigan Concrete of Bensonhurst and Brooklyn Lithogranite on Atlantic Avenue both poured concrete sidewalks. And the Wilson & Baillie Manufacturing Company made "KOSMOCRETE sidewalks."

Sometimes it is important—and educational—to watch where you walk.

Cobble Hill

Long Island College Hospital

June 28, 2007

Every once in a while, healthcare looms into focus. So it happened to me when I needed a medical procedure. Since Brooklyn operated as a city until the end of the nineteenth century, many services functioned here that would not be in place in a smaller community. Therefore, Brooklyn had a mayor, a court system, police and fire services and both public and private hospitals. City, county and state services operated here.

During the nineteenth century, identity with Long Island was more important than with Brooklyn. Therefore, we had the Long Island Historical Society instead of the Brooklyn Historical Society and the Battle of Long Island rather than the Battle of Brooklyn. Long Island was long considered the backyard of Brooklyn and its logical extension. While some names have modernized, Long Island College Hospital, the Long Island Rail Road and Long Island University retain their original names.

BAM has always been the Brooklyn Academy of Music, as have the Brooklyn Museum, the Brooklyn Public Library and the Brooklyn Children's Museum been so named, although all operated under the umbrella name Brooklyn Institute of Arts and Sciences.

In the center of Kings County stood the county buildings, which included Kings County Hospital, a series of buildings founded in 1831. In the nineteenth century, other county buildings in the area included a home for inebriates, an almshouse for the indigent and a state prison. In 1892, Coney Island Hospital joined the city hospital system. In 1895, Brooklyn State Hospital opened near the county buildings.

Some private hospitals became teaching hospitals for doctors and nurses. Long Island College Hospital (LICH), where I went, was founded

Long Island College Hospital (1836), including Joseph A. Perry mansion, circa 1910. *Brooklyn Historical Society.*

by German immigrants in 1857. In 1860, the hospital created the Long Island College of Medicine, the oldest hospital-based medical school in the country. Among its original staff members were a leecher and a cupper, according to *The WPA Guide of New York City.*

The original buildings, designed by D. Everett Waid and William Higginson, were completed between 1897 and 1916. Long Island College Hospital featured the country's first private bacteriological laboratory, erected in 1888 at 335 Henry Street and named the Hoagland Laboratory after Cornelius Hoagland, the founder of Royal Baking Powder and a benefactor who lived on Clinton Street. The laboratory burned down. Today, several outbuildings remain at the corner of Henry and Amity Streets, including the Dudley Memorial (1902), originally a nurses' residence designed by William Hough to reflect French Renaissance architecture; and the Polhemus Pavilion from 1897 (designed by M.L. Emery), where I went.

The rest of the buildings that compose the hospital around Atlantic Avenue and Hicks and Amity Streets are modern: E.M. Fuller Pavilion (1974), Polak Pavilion (1984) and the Ferrenz and Taylor addition (1988). Among innovations, LICH introduced the practice of bedside teaching in 1860 and became the first U.S. hospital to use stethoscopes and anesthesia.

By 1930, the Long Island College of Medicine incorporated as a separate medical school. In 1954, the College of Medicine allied with the State University of New York and still remains the primary teaching affiliate of SUNY-Downstate Medical Center.

Today, LICH has a reputation for its work in radiology and research projects. The hospital is affiliated with Continuum Health Partners and has become the sixth largest hospital in Brooklyn, according to Francis Morrone in his *Architectural Guidebook to Brooklyn*.

Brooklyn Banks on History

August 16, 2007

The corner of Court Street and Atlantic Avenue has served history well. During the Battle of Brooklyn, General George Washington observed the attacks of the Maryland militia on British troops. From this point, he could see the Old Stone House in Gowanus. On the front of the building standing there, the incident is memorialized on a plaque.

At the same time, three guns protected the high point known to soldiers as Corkscrew Fort because of the tortuous path to climb to the top. The Dutch called the spot "Ponkiesberg." The British knew it as Bergen Hill, but Massachusetts troops named it Cobble Hill for the rock ballast lying around. Even though the neighborhood is still known as Cobble Hill, the British leveled the hill for military reasons during their occupation.

In the 1840s, a railway tunnel ran down the center of Atlantic Avenue; now abandoned, it serviced shipping at the waterfront. A decade later, the South Brooklyn Savings Institution was established. By the 1920s, nondescript two-story frame buildings bordered the trolley tracks on both Court Street and Atlantic Avenue. In 1924, South Brooklyn erected a massive sixty-foot bank building on the corner that the *Brooklyn Standard* reported destroyed Brooklyn landmarks: a hardware store and a dry goods business.

In time, the bank itself changed names from South Brooklyn to Independence to Sovereign Bank. Now history moves on, with a condominium going up in the bank's parking lot and the bank building itself about to be transformed into Trader Joe's.

In July, Sovereign commemorated the official move of the bank operations to the new Court House quarters across Atlantic with a farewell community open house. To mark the building's seventy-five years as a bank, Sovereign teamed up with the Brooklyn College Library and the Brooklyn Historical

Society for a public display of exhibits, on view for weeks leading up to the open house, at which over 150 community, civic and bank employees—both present and retired—appeared.

One exhibit, titled "Roots of Modern Brooklyn: A Look at the 1970s and 1980s," reflected the significance of South Brooklyn's role in supporting the emergence of the brownstone community revival in northern Brooklyn. Since 1850, South Brooklyn and later Independence were among the few banks that continued to make mortgage loans in spite of the prevalence of redlining practiced by many other financial institutions.

Other historical artifacts on view came from the bank vaults and archives, with displays of handwritten ledgers. The association of the bank with several of Brooklyn's noted leaders was instrumental to its success; namely, James Stranahan, who was pivotal in the creation of the Brooklyn Bridge and Prospect Park, and John Taylor, an attorney who founded the Brooklyn Athenaeum in the nineteenth century.

Parts of the exhibit had been prepared and exhibited by Brooklyn College's Library and Archives. Materials from the history of the banks have been bequeathed to the Brooklyn Historical Society. Toward the end of 2007, the Brooklyn Historical Society prepared an exhibit using material from the bank's and the college's collections. According to Brooklyn Historical Society's president, Deborah Schwartz, the exhibit also included a more extensive presentation of an oral history project involving bank leaders, a portion of which was on view at the bank open house.

DUMBO:
Not a Pink Elephant

April 7, 2005

D UMBO. What a dumb name for a neighborhood! Many visitors to the borough can't believe it when they hear the word. But then they also mispronounce Houston Street, Greenwich Village and never get through Joralemon. Let's just call it "Beneath the Bridges." Paradoxically, it is one of Brooklyn's oldest yet newest neighborhoods. You might say it's reaching maturity faster than Britney Spears.

Only yesterday, it was a relic of deserted warehouses and tracks from the Jay Street Interconnecting Railroad embedded in the streets' Belgian blocks leading to nowhere. In fact, Robert Diamond, the trolley preservationist, stored an old trolley in one of the barns before he moved it to Red Hook. Today, he couldn't afford the rent.

Now the streets are bustling with delivery trucks for a gourmet food shop, art galleries and an exclusive wine shop. Boutiques have surfaced, theatre is alive in St. Ann's Warehouse and Jacques Torres sells his delicious, freshly made gourmet chocolates there. Even a bus has a regular route and schedule.

While the din of traffic today is from the overhead Brooklyn-Queens Expressway and the Brooklyn Bridge, years ago it was from heavy industry. Shortly before the Civil War, shippers and manufacturers found this patch of the East River shore long before bridges connected the cities of Brooklyn and New York.

In 1854, the heart of Brooklyn's business community lay on Old Fulton Street, which leads down to the Fulton Ferry pier. Since Brooklyn had a natural harbor, Empire Stores was constructed as a warehouse. During the wartime years, Navy Yard shipping made good use of it to transport military supplies. After the war, the waterfront became even busier.

The government built the Brooklyn Tobacco Inspection Warehouse for U.S. Customs use in 1886. Then the Grand Union Tea Company joined it in 1893. One Main Street—the clock tower—had been offices of the Gair Company, purveyors of folded cardboard boxes since 1879. The company

moved to the area now called DUMBO in 1887. Finally, Robert Gair had ten buildings, and the area began to be called "Gairville." More recently, the building was used for New York State offices, while several restaurants have tried their luck there.

In 1898, the Arbuckle Company, a coffee-packaging company, opened a sugar refinery in DUMBO, storing its supplies in the Empire Stores. About the same time, the E.W. Bliss Company opened a factory for stamping out metal cans. The Sweeney Building up the road at 30 Main Street now serves condo residents instead of the kitchenware Sweeney produced before.

By the 1930s, businesses started to move to other sections of the country to save labor costs. This accelerated until a mass of derelict buildings lined the deserted streets. In the 1970s, artists driven from Greenwich Village and SoHo by rising costs moved into these shells and set up studios.

David Walentis, a Brooklyn developer, bought out many of the buildings, while New York State Parks claimed the Empire Stores, the Tobacco Warehouse and the land abutting the East River for Empire State Park. As the condos were completed, the territory began to change. Art dealers moved in with the artists, followed by dance and theatre companies. Washington and Front Streets spruced up and Independence Community Bank (now Sovereign Bank) rented out space.

DUMBO is on its verge. The city Parks Department improved the playground by the river, including a nonswimming beach. Gold's Gym moved there, and St. Ann's Warehouse Theater, forced out of Brooklyn Heights, attracted Al Pacino and Marisa Tomei to sold-out performances. The future portends that the new super Brooklyn Bridge Park will blossom to the west along the East River waterfront.

Outside the parameters of DUMBO lie the Fulton Ferry, Vinegar Hill and the Brooklyn Heights historic districts. Under the Brooklyn Bridge, the River Café is moored on one side of the Fulton Ferry Pier and Olga Bloom's Bargemusic on the other. In the middle is the Ice Cream Factory in an old firehouse next to a berth for the new water taxis. Down Old Fulton Street is the famous Grimaldi's Pizza. And across the street are the old offices of the *Brooklyn Daily Eagle*.

Oh, yes, the meaning of DUMBO? All together now: "Down Under the Manhattan Bridge Overpass!" DUMBO was landmarked in December 2007.

Park Slope's "Whale and Squid"

January 26, 2006

Not quite an accurate title, since Brooklyn's Park Slope has neither an aquarium nor a natural history museum. Nor has it a whale or a squid, to the best of my knowledge, or even a pub with that name. But it does have some notoriety these days as a result of a recent film set there.

What is Park Slope? Is it the residence of the spoiled, misinformed, overeducated yuppies in the movie? Or is there substance behind those brownstone walls? Are they really so amoral and clueless? Keep in mind we're talking about the North Slope, that section adjacent to Prospect Park West, Grand Army Plaza and the subways. It's all so Kafkaesque!

First of all, it's expensive. Not Sutton Place expensive, but pricey. Architecture—the gaudy Victorian type rejected in the mid-twentieth century—escalates the costs. The spires, turrets and bay windows are just the façades of the houses, as well as of the inhabitants. Those versed in the terms French, Greek, Romanesque and Queen Anne appreciate these touches. Fireplaces, wainscoting, pocket doors, gourmet kitchens, four-posted beds and floor-to-ceiling bookcases complete the picture.

Not to mention being in walking distance (particularly for those living on the choice streets, either named or lower than Ninth Street) of Prospect Park, the Central Library, Brooklyn Museum, Botanic Garden and the green market in Grand Army Plaza.

Add to that the shops on Seventh Avenue, restaurants on Fifth and the mock Venetian palazzo Montauk Club on Eighth. The Historic District proudly relishes the tree-lined streets representing gaudy tastes of the nineteenth century, when millionaires built in this verdant outpost of Prospect Park. Two city-landmarked buildings from that period lie within the Park Slope parameters: the Cronyn House on Ninth Street and Public School 39 on Sixth Avenue. The most notable collection of houses can be found on Carroll Street and Montgomery Place. Neighborhood public transportation is good; parking is not.

As seen in the movie, a large percentage of the Slope's residents are professional intellectuals or pseudointellectuals: academics, writers, editors, lawyers. The private schools and services are good to superior. Houses of worship border between historic and socially conscious. The most prominent collection of lesbian research material is housed in local archives.

At one time, when the banks of the canal were sylvan farmland, Park Slope was part of Gowanus, but gentrification thought that the name was a bad choice—as well as a bad smell. Today, residents tend to be from "elsewhere," including some true celebrities who are relocating there. Essential amenities—such as Starbuck's, Barnes and Noble and sushi bars—complete the picture. On weekends, stoop sales, advertised by notices stapled to telephone poles, satisfy residents as well as visitors. The Park Slope Food Co-op on Union Street specializes in organic products and is staffed by co-op members.

Basically owned and developed by Erastus Litchfield, Park Slope remembers him with the Litchfield Villa, once known as Wave Hill and now the headquarters of the Brooklyn Parks Department. Originally settled by Dutch farmers, the land was platted in the nineteenth century in preparation for the development seen today.

Socially, the biggest annual events are the Seventh Heaven Street Fair, a gigantic flea market held every fall, the Irish American Day parade in March, the Park Slope House tours in May, and the Great Pumpkin Festival and Halloween Parade in October. Adjacent to Park Slope, a New Year's Party, hosted by the borough president, is held on New Year's Eve, with festivities in Grand Army Plaza and fireworks in Prospect Park.

Prospect Park hosted another type of party during the American Revolution, of course. In 1776, the rebels—outflanked by British troops—fought valiantly at Battle Pass before proceeding to the Old Stone House and, eventually, escaping across the East River to live and fight another day.

While the North Slope was the focus of the film, the South Slope has reached a gentrification stage, with affluence spilling over and down. Most notable has been the conversion of the Ansonia Clock factory on Seventh Avenue and Twelfth Street into co-operative apartments called Ansonia Court. Even Fourth Avenue and neighboring Windsor Terrace now receive part of the added value.

In spite of the opinion of some that Park Slope is an overheated "minor work unworthy of Fitzgerald," it has charm and a magnetic quality that will continue to draw wealthy yuppies. Which is the whale and which the squid?

Now, if only the real estate bubble would burst.

Sheepshead Bay

Lundy's: A Fishy Sheepshead Tale

February 22, 2007

The same week as Pfizer announced its closing, Lundy's Restaurant in Sheepshead Bay shut its doors. Actually, the doors were closed and barred by the landlord in January, so the restaurant had no alternative. But this latest act remains only the most recent in a history of untoward activities associated with Lundy's.

Once, Lundy's stood as the center of social and gustatory life in Sheepshead Bay. On Sundays, neatly dressed diners filled most of its twenty-eight hundred seats to eat a weekend meal there. No reservations and no headwaiters—just hungry diners enjoying a family gathering, filling the cavernous Spanish-motif rooms with noise and clattering dishes. If you spotted a family finishing dessert, you hovered over the table to grab the seats the second they rose. Lundy's, from the 1930s through the 1950s, represented a way and a ritual of life.

But that changed after Tam Corporation reopened the newly landmarked building in 1995. Wisely, they reduced the size of the huge rooms. The product being sold was no longer fresh seafood, but nostalgia at twice the price. While the stability of Lundy's to a changing neighborhood was welcomed, you knew it wasn't the same once you sat down anymore than you were the same.

I met Chris, the maitre d' (the new owners hired one), several years ago. "It's changed," he told me. "The new families no longer have the memories or association." Gone was the camaraderie. And that's what did in the latest reincarnation of Lundy's.

Sheepshead Bay, once the racing capitol of New York and Brooklyn cities, attracted the big spenders, some of whom built their "cottages" in

Lundy's Restaurant from Sheepshead Bay Bridge, circa 1935. *Kingsborough Historical Society.*

Lincoln Beach, commonly known as Millionaires' Row. Celebrities flooded to southern Kings County. And then there were unsavory types.

This was the world in which Irving Lundy, born in 1895, sold fish on a pier off Ocean Avenue, near the main entrance to the track. The tracks lasted until 1910, expiring slowly, kept alive by specialty shows and, in 1915, by horseman Harry Harkness, who created Sheepshead Bay Speedway, which operated until his death in 1919. In 1923, the property was sold to Joseph Day for development.

With the arrival of Prohibition, Irving Lundy, his brothers and employees earned extracurricular salaries by running booze in their boats as well as fish. The profit enabled Irving to buy the property owned by the McMahon family on the corner of Ocean Avenue in 1926. In 1934, he had the former Bay View Hotel demolished and opened his Mediterranean-themed restaurant on October 15.

Once Irving Lundy was the wealthiest man in Sheepshead Bay. He built a gargantuan barn of a restaurant in 1934, during the heart of the Depression, spinning off on the past glory of Victorian Sheepshead Bay. It was a gamble and he won. He not only succeeded in the restaurant business, but also bought up property and other businesses throughout Sheepshead Bay. Later, in the down days of the 1970s, the Bay looked depressed with closed shops and his empty lots.

The Lundy family history in Brooklyn predates that of Charles Pfizer. Frederick Lundy, an ancestor, came to Brooklyn in 1838 under the auspices of the van Nostrand family. His sons and their families opened fish stores and sold fresh fish to Coney Island and Manhattan Beach hotels in days when the lack of refrigeration meant that food did not travel well. Fish lovers found the fish; fish did not travel to them.

Lundy's entrepreneurship gained him a keystone in the revival of Sheepshead Bay, the restoration of the community from its days as a playground of the rich. Now the middle class could enjoy eating fish in the cool ocean breezes.

The city encouraged revitalization of Sheepshead Bay, and Lundy's fit in. Developers called it New Flatbush, while the city dredged the bay, widened Emmons Avenue and rebuilt the piers. Because of its unique design, Lundy's stood out with its maroon awning, tiled roof, stained-glass windows, two-storied dining rooms with patio dining, two kitchens, a clam bar, a liquor bar and marble stairways.

Its kitchen specialized in lobster, biscuits, chowder, clams and Breyer's ice cream on top of fresh fruit pies. The many new customers found average restaurant eating too demanding, but Lundy's became special with its lobster bibs and finger bowls.

When FWIL Lundy's opened, Sheepshead Bay had a proven track record as a popular watering hole for society's playboys and racing touts. The neighborhood in mid-century had been Irish, then Italian and Jewish. The wait staff—African Americans whose families dated back to the nineteenth-century racetrack—lived on East Fifteenth Street and Gravesend Neck Road all their lives. Over 220 waiters served more than five thousand meals a day.

The success of Lundy's encouraged other restaurants to join the "fishing fleet." Pappas opened next door on Emmons; Villepigue's on Ocean Avenue became a Lundy property, as did Tappens, which moved to the Villepigue's site. Later, Jenns, Ross-McGuiness and the Log Cabin opened, followed by the Barge, Ferrara's and Randazzo's. Then Tappens burned in 1950.

By the time Hamilton House opened a subsidiary where Billy Sheirr's roast beef had been served, Sheepshead Bay turned the corner. Hamilton House became Charlies, then closed.

Lundy's waiters tried to organize in 1957, then walked out. The feds cracked down on forty illegal immigrants working for Lundy's in 1976. Irving Lundy began losing money, and he attempted to develop an entertainment center in Sheepshead Bay, but the city denied him a license.

Then, his chauffeur murdered Irving—who was a recluse and so fearful of his life that he seldom ventured out of his room—for his money. With a

paranoia that closed in on Irving Lundy in his later years, a labor issue in 1957 and Lundy's bizarre murder at age eighty-two, the restaurant officially closed in 1979 and was sold to the Litus Group in 1981 for $11 million. While sealed and abandoned, it received landmark status in 1991 for its "special character, special historical and aesthetic interest." I supplied much of the history used to support this designation.

With this new honor and attention on the building, Frank Cretella bought it and redesigned it to use 42 percent of the original space, seating seven hundred as opposed to twenty-eight hundred. Lundy's reopened in 1997, selling four clams, four oysters and six mussels for $24.95. Clam chowder now cost $4.50, and the famous Shore Dinner (formerly $4.95, then increased to $8) was $39.95.

The original Shore Dinner, supposedly ordered by "Diamond Jim" Brady at Villepigue's, consisted of: choice of soup; clams, oysters and shrimp; a crabmeat cocktail; steamers; half a broiled lobster *plus* half a broiled chicken; potatoes; vegetables; Breyers ice cream or fresh fruit pie; and coffee, tea or milk. A glass of Trommers White Label was extra.

The Tam Corporation, leasers of Central Park's Boat House Cafe, tried its best, introducing special occasions, entertainment and promotions, and even an ancillary Lundy's opened in Times Square. But it never clicked again. Tam blamed it on the unrest after 9/11. Trouble lurked in corners. On May 6, 2003, Lundy's was closed by New York State for nonpayment of taxes. The next day, Tam filed for bankruptcy and reopened. By 2004, they sold out to the Players Club run by Mrs. Afrodite Dimitroulakos.

Today, Sheepshead Bay is the focus of senior and assisted living developments. While it still attracts crowds on warm Sundays, they no longer line up at Lundy's. Still, the fishing boats attract passersby, the water is peaceful and the chain restaurants beckon with promise.

The new Russian and Asian population had no recollection of the heyday of Lundy's or the colorful history of Sheepshead Bay. They knew no one who had looked forward all week to a Sunday Shore Dinner at Lundy's. So business was down.

Lundy's has been closed again. Since it is landmarked, a high-rise will never appear on the corner of Ocean and Emmons Avenues, and most likely another restaurant—or maybe another Lundy's?—will open there. It happened to Gage and Tollner's. Fridays, anyone?

(For more information about Lundy's, including original recipes, see *Lundy's: Reminiscences and Recipes from Brooklyn's Legendary Restaurant* by Robert Cornfield.)

PART VI

Away We Go!

Ferryboat Serenade

August 4, 2005

Today, water taxis and high-speed ferries zip back and forth over the bodies of water that surround most of New York City. Since 9/11, we have reverted to water transportation as we have absorbed ferries as part of the city's ambiance. But a generation ago, most ferries were considered an anachronism. Construction of many of the city's bridges since the nineteenth century has replaced the need for ferries and water transportation for commuters. Public opinion ignores the need for ferry service and the crucial role of water transportation for an urban archipelago.

The first Brooklynites commuted to Brooklyn Heights in 1642 courtesy of the Cornelius Dircksen ferry. Those early ferries were either large rowboats or catamarans and were powered by oars or sails. Long before the Brooklyn Bridge appeared, steam ferries transported passengers and vehicles from Fulton Street, Manhattan, to Old Fulton Street, Brooklyn, courtesy of Mr. Fulton and William Cutting. By 1836, ferries from Whitehall Street, Manhattan, pulled into Brooklyn's South Ferry, the early name for Atlantic Street (now Avenue). A decade later, the Hamilton Ferry operated between the Battery and Hamilton Avenue, Brooklyn. In 1854, the ferry lines consolidated into the Union Ferry Company. The fare, by the way, was two cents.

Ferries transported Williamsburg residents to their Manhattan jobs. In fact, six ferries left for Peck Slip every ten minutes and for Grand Street every five minutes. By 1860, East River ferries conveyed a hundred thousand passengers every workday. Ten years later, commuter travel increased to 50 million a year! Brooklynite Walt Whitman wrote his poem, "Crossing Brooklyn Ferry" in tribute to water transportation.

Ferry boat design changed to double-ended boats and then to side-wheelers. All transported pedestrians as well as horse-drawn vehicles. In the nineteenth century, railroads operated most of the ferries: Baltimore and Ohio, Jersey Central, Pennsylvania, Erie Lackawanna, New York Central, Long Island Rail Road and Public Service Railroad.

Two ferries connected Brooklyn to Staten Island before the Verrazano-Narrows Bridge appeared. They were operated by either the Brooklyn Union Ferry Company or the Electric Ferry Company. A ferry from East 23 Street, Manhattan, docked in Greenpoint and then passengers rode the Long Island Rail Road through East New York, Flatlands and Sheepshead Bay to Manhattan Beach. Others ran from the Battery to the Coney Island piers. Ferries crossed Jamaica Bay from Canarsie to the Rockaways. Others ran from Barren Island to the Rockaways. From Sheepshead Bay, ferries ran to Plum Island (now Plumb Beach) and from the Bay to Breezy Point in the Rockaways.

Both the Staten Island and Governor's Island ferries still serve their island residents and guests. They remain the most famous and visible water services. Ferries to Governor's Island, Liberty Island and Ellis Island are operated by the federal government, the Park Service and private companies. The Staten Island ferry, no longer a car-carrying boat, is free and is still run by the City of New York. New boats have been added to the fleet, as well as bright new terminals on either end. In Richmond, the ferry docks at St. George, a former section of New Brighton. In 1880, it was renamed St. George by Erastus Wiman, a developer, who was so grateful to George Law, the owner of the land and a politician, that he blessed him with sainthood. Without Law's help, Wiman would not have been able to consolidate his railroad at the ferry.

In the heyday of ferry travel, Brooklyn boasted twenty-three ferry lines, including five railroad ferries, one sailing from the foot of Montague Street, where a former passenger ferry had moored. One of the last rail ferries sailed from the Brooklyn Army Terminal yards to New Jersey. With the construction of bridges and tunnels, ferries lost favor. The last official passenger ferry crossed the East River in 1925, although unofficially ferries ran until the 1940s. The 1980s saw the first attempt to revive ferry service, partially prompted by gasoline shortages. Now, of course, high speed ferries are here, but only the Staten Island ferry carries on the old tradition.

As a tribute to the city's maritime history, a ferry should be honored and preserved in Brooklyn. What happens to the old decommissioned ferries when new ones are introduced? They retire to the Red Hook docks or to the Staten Island ferry graveyard, near Tottenville.

Why couldn't one of those beautiful mammoth boats be recommissioned and retrofitted or renovated as a quality restaurant off the shores of the new Brooklyn Bridge Park? We already have a Bargemusic and a pricey River Café. Over in Red Hook, we have a Museum Barge. But a large ferry restaurant at the Atlantic Avenue entrance to the proposed park would be another Brooklyn success.

Up in Portland, Maine, the DeMillo family did exactly that. Their ferry restaurant is the most popular one on the Maine waterfront. Why not Brooklyn?

In the summer of 2007, the most successful waterfront attraction was the swimming barge at Brooklyn Bridge Park-to-be. An oil tanker became the stage for an opera sung in Red Hook. How about *al fresco* theatre, as on River Walk in San Antonio, *plus* a ferry restaurant?

Brooklyn's Trolley Strike

February 9, 2006

The three-day MTA strike that got New Yorkers walking and talking together in December turned out to be more of a social event than the labor riots that workers staged in prior times. And one of the biggest and most violent happened in the City of Brooklyn in 1895.

The year 1895 occurred between the annexation of the towns of Flatbush, Gravesend and New Utrecht (1894) and the annexation of the town of Flatlands (1896), the last independent town in Kings County. In 1895, a fire blazed in Brooklyn City Hall in which the cupola burned. Three years from then Brooklyn would be reduced to a borough.

Officially, the strike's name was the Brooklyn Surface Railroads Riot because trolleys ran on tracks, just as trains do. Effects of the strike are described by Theodore Dreiser in his novel of social consciousness, *Sister Carrie* (1900). The main character, George Hurstwood, a cultured, middle-aged married man, is reduced to accepting work as a labor scab motorman during the Brooklyn strike as a result of his affair with a young actress. Dreiser, a former reporter, had a journalist's eye for details.

The controversy started in January with protests from the trolley motormen on the Putnam Avenue–Halsey Street line for a twenty-five-cent raise. In those days, the transit lines' elevated routes, as well as trolley routes, were privately owned. Subways existed only in Manhattan. Brooklyn had many surface rail lines.

Trolley cars hardly exuded the romance of "The Trolley Song." Basically, the ride was harsh and noisy. Without air conditioning, summer days could be stifling, but open cars alleviated the heat. In winter, the passenger section was enclosed with a stove inside but the motorman rode on a platform outside. Regulations, strikers claimed, were oppressive. The strike started January 14.

Labor disputes at that time did not adjourn to the mediation table. Because unions had organized only recently, no laws existed against strikes.

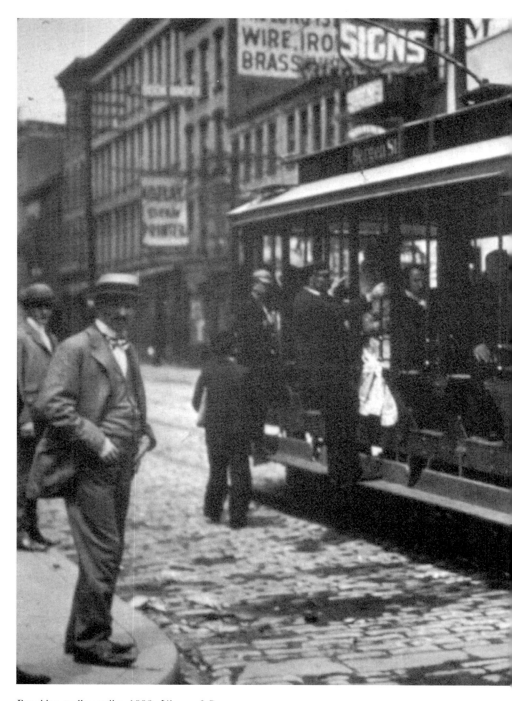

Brooklyn trolley strike, 1892. *Library of Congress.*

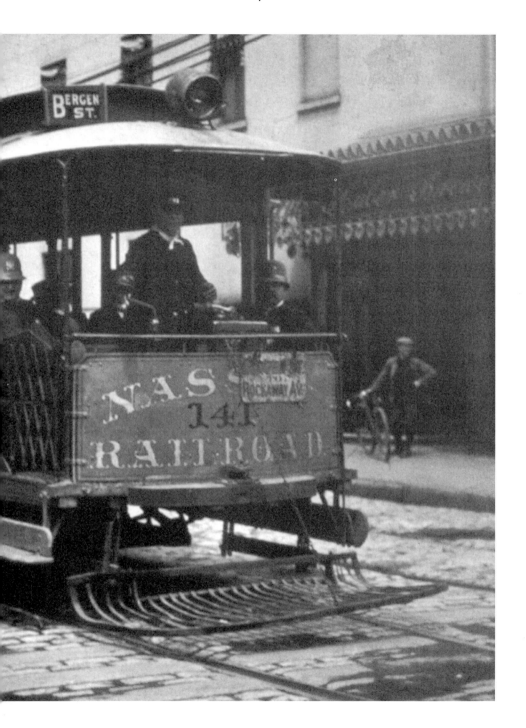

Owners considered strikers radical and un-American. Only a walkout could affect management.

A privately owned company was considered personal property, and its rights were defensible by any means necessary. In 1892, the Homestead Strike against Carnegie Steel in Pennsylvania pitted armed Pinkerton guards against unarmed strikers and their families. *Harper's Weekly*, in opposition to strikes, charged that the Brooklyn trolley strike was an application of a lynch law inviting "working men everywhere to coerce employers to their demands by disorder and violence."

In Brooklyn, armed strikebreakers fought striking workers. Strikers fought back. They tore down trolley wires, damaged tracks, fought police and attacked the labor scabs brought in by management to keep the trolleys running. Eventually, the militia was called in. On January 22, the first striker was shot by the soldiers. He died the next day.

Over seven thousand militiamen attacked the strikers' lines with drawn bayonets. Strike leaders claimed the Seventh Regiment was employed by politicians and big money interests. (Ironically, this New York State unit refused to fight in Cuba during the Spanish-American War three years later.) The strike was broken February 2. *Harper's* declared that civilization had "no choice but to put them down."

A song called "The Brooklyn Strike" appeared at the height of the violence. Its verse showed obvious sympathy for the strikers.

> *I walked through Brooklyn City not many days ago.*
> *The working men were idle, for out they had to go.*
> *The bosses of the railroads refused them honest pay, Defying arbitration,*
> *Cooley* [union leader] *bid the men obey.*

> Chorus: *Remember, we are working men, and honestly we toil; And gentlemen, remember, we were born on Brooklyn soil, Nor can the pampered millionaires, the spirit in us break. The fame of our fair city is clearly now at stake.*

> *The soulless corporations should know this lesson pat.*
> *A fair day's work for a fair day's pay is what we're aiming at;*
> *They cannot run their trolley lines with lazy dudes and tramps, With safety to the public long, who detest vile scabs and scamps.*

I don't think it would sell in today's market, but for a three-day strike, not even a rap song could be created. They don't make strikes the way they used to.

Brooklyn Derailed

April 26, 2007

As Brooklyn's Pier 1 is emptied and exposed in preparation for Brooklyn Bridge Park construction, rail tracks have surfaced in the former parking lot, revealing a vestige of a once-extensive dockside railroad network. These trains helped Brooklyn's shipping industry operate before and during World War II.

Rails can be found in the Navy Yard, by the shore in Williamsburg, in streets of DUMBO, along the perimeters of the city piers and on a listing dock at the foot of Montague Street. Farther on, they emerge in Sunset Park at Bush Terminal and the former Brooklyn Army Terminal.

Brooklyn's first passenger railroad began running after 1836—and later became the Long Island Rail Road—but cross-county (Kings) railroads had to wait until after the Civil War to be constructed.

Trains to move freight around Brooklyn's many docks started in 1875 with the East River Terminal. In Williamsburg, the Havermeyer family initially used trains to move heavy supplies between their sugar factories and ships. In time, Havermeyer Sugar became Domino Sugar. Their terminal existed until 1906, when it grew into Brooklyn Eastern District Terminal. In 1978, New York Dock, organized in 1901, purchased Eastern District.

Locomotives belched steam and frightened both horses and humans, so many were disguised to look like passenger cars or trolleys with small vertically mounted boilers. They were called "dummy engines." In high traffic areas, a man on horseback carried a red flag to warn of the approaching locomotive. By 1963, diesel engines replaced the steam engines. The last steam engine, repainted, rested in the Bush Terminal Cross Harbor Railway yards in 1999 until it was shipped to the Railroad Museum of Long Island, reported Doug Diamond, a Brooklyn railroad enthusiast.

In the heyday of rail transportation (before Amtrak), all the major rail systems ran from New York City's docks: Pennsylvania, New York Central; West Shore; Erie; Delaware, Lackawanna and Western; Boston and Ohio

Tracks for freight cars at the Montague Street ferry pier, circa 1945. *Photo by Irving Herzberg. Brooklyn Public Library, Brooklyn Collection.*

(B&O); Central Railroad of New Jersey; Lehigh Valley; Reading; and New York, New Haven and Hartford. B&O even operated the municipal rail system on Staten Island, before MTA took it over.

Brooklyn's own commercial railway was the South Brooklyn Railway, which ran Transit Authority equipment along Gravesend (now McDonald) Avenue from the yards at Thirty-ninth Street and Second Avenue to the Coney Island yards. Where streets crossed McDonald, railway crossing signs appeared on the pavement. The run ceased in 1978.

Terminals from which these railroads operated included East River, Bush, Fulton, Baltic and Atlantic terminals. The Atlantic, Baltic and Fulton were car-float bases. Three other large dock terminals merged and operated into the later twentieth century under the names Bush Terminal (Sunset Park), New York Dock Terminal (Bay Ridge) and Jay Street Connecting Terminal (Brooklyn Heights).

With a focus on modernizing transportation, trucks and buses replaced trains and trolleys, and roadways replaced railway beds in the 1950s. As this transition occurred, New York Dock rebuilt and modernized the Atlantic Terminal in 1963. Inevitably, the Brooklyn dock terminals closed, beginning

with the Jay Street Connecting Terminal in 1959, followed by the Bush Terminal in 1972 and New York Dock Terminal in 1983.

With a decline in shipping, the Brooklyn waterfront attempted to survive by converting open docks into container ports, but the Port Authority didn't have as much space in Brooklyn as it did in New Jersey. Added to this plight were the failure of Penn Central and the rise of Conrail.

Since rail shipments proved to be more commercially and environmentally profitable, the New York Regional Rail emerged out of New York Cross Harbor in Bay Ridge, using facilities in Bush Terminal. This route serves over 280 miles up the Hudson River and provides an interchange between New York and New England. It also reduces truck traffic and pollution in the streets of Brooklyn.

Brooklyn's LIRR

May 17, 2007

In or about 1832, Brooklyn built its first railway to move produce and hardware from Jamaica, then in Long Island outside the city, to the Village, and later City, of Brooklyn. Initially, and logically, this line was called the Brooklyn and Jamaica Railroad.

By 1834, the Long Island Rail Road was chartered and leased track from B&JRR, then continued its own rails to the east to provide rapid access between New York and Boston. This route was completed by 1844.

This was not Brooklyn's only railroad—all our subway routes, except the Fourth Avenue subway, originated as independent surface railways. Other individual Brooklyn railroads included the Brooklyn City and the Brooklyn Heights Railroads.

But the LIRR has been an important cog in our rail system the longest and is the oldest railroad operating under its original name, as well as the nation's busiest commuter railroad. The Brooklyn terminal building opened in 1907; on April 1, 2007, it celebrated its centennial year. Now the Atlantic Avenue Terminal is undergoing a $93 million renovation and reconstruction due for completion in 2008, making it an important hub in the inevitable Atlantic Yards project.

Today, instead of one daily train, the LIRR comprises over seven hundred miles of track on eleven different branches, carrying an average of 274,000 passengers daily, according to the MTA/LIRR website. About two hundred trains originate or terminate at the Flatbush Avenue terminal. Whereas the terminal once housed Loft's Candies and Bickford's Restaurant, it now offers shopping for patrons of Target and Starbucks.

Originally, the tracks ran east along Main Street, today's Fulton Street. When the Atlantic Avenue terminal opened, it was the epicenter of several trolley lines. However, Brooklyn banned steam engines in city limits in 1860, so people and produce needed to be transported from Jamaica to Brooklyn by horsecars and carts.

By 1880, Austin Corbin, a banker, bought the LIRR and made it profitable, with new steel rails and wooden "excursion" coaches that traveled from Greenpoint and Bay Ridge to his hotels in Manhattan Beach. Corbin planned a deep-water port at Fort Pond near Montauk to provide transatlantic shipping to Europe. While plans progressed, Corbin died from an accident before they could be finalized. The Pennsylvania Rail Road purchased the LIRR, making Pennsylvania Station its New York base.

In Brooklyn and Manhattan, once electric power was substituted for steam, housing developers in Park Slope and Prospect Park South advertised the proximity of the LIRR to their properties. The same claim arose from the many department stores and theatres in downtown Brooklyn.

With the rise of travel by car, creation of Long Island highways by Robert Moses and improved air transportation after World War II, passenger travel on the LIRR fell off. Eventually, New York State acquired the LIRR after PennCentral, its new owner, declared bankruptcy.

Today, the selling point of the LIRR is its proximity to New York City's subways. Could it be that they are both properties of the MTA?

The Flatbush Terminal, its latest name, has six tracks that house eight- and ten-car trains. Trains from this station are called the Atlantic Branch and run sixteen miles through Brooklyn and Queens, ending in Valley Stream.

Future plans include changing Flatbush Avenue from a terminal to a station on a new route to a proposed station on Broadway in Lower Manhattan. By 2012, the LIRR hopes to initiate service into Grand Central Terminal, as well as Penn Station.

Until the mid-nineteenth century, the LIRR operated freight across Brooklyn from Greenpoint to the South Brooklyn Railroad in Sunset Park. A freight station was located near Flatbush's junction, with trains passing behind Brooklyn College. The tracks had originally been those of the Manhattan Beach Railroad. Now talk of using those tracks for freight destined for New Jersey has resurfaced. While the line will be independent of the LIRR, it means that rail service will again be important to Brooklyn.

Floyd Bennett Field

April 17 and 24, 2008

New York's Gateway National Recreation Area celebrates a thirty-sixth anniversary this year. Facing that reality is similar to realizing that your children have turned into adults and now you're a grandparent.

Not only is Gateway mature, but it has also spawned four children. Officially they are called "units." Their proper names are Jamaica Bay, Breezy Point, Staten Island and Sandy Hook. The National Park Service manages all since Gateway's creation in 1972. As of 2005, attendance at Gateway numbered over 8 million visitors, in excess of attendance at Yellowstone and Grand Canyon National Parks.

All of the areas are nature preserves and wetlands, with recreational and educational activities. But what was Gateway before the federal government managed it? Well, the government always lurked in the shadows from the time of Jamaica Bay's inception as New York's first municipal airport. Before that creation, Barren Island had been Gravesend's waste disposal system.

Initially, Barren Island was the largest salt marsh in Jamaica Bay. Native Americans had named the group of islands "Equindito" or "Broken Lands." An early nineteenth-century resident named Dooley operated an inn for sportsmen. In 1859, entrepreneuring businessmen set up various industries on Barren Island, including garbage disposal, fish oil processing and fertilizer manufacturing. As the fertilizer business profited from rendered animals, Dooley's Bay was renamed Dead Horse Bay. Horse rendering remained a staple industry until 1921.

As a result of the lucrative but smelly businesses, a community of fifteen hundred inhabitants developed by the last decade of the nineteenth century with stores, a school and two churches. A small boat commuted between Barren Island and Canarsie. However, Barren Island lacked water and sewer systems.

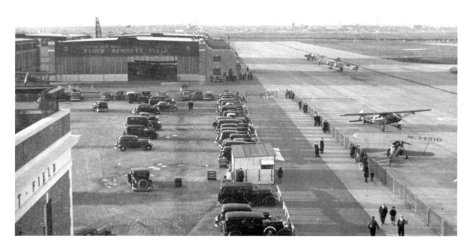

Floyd Bennett Field runway, circa 1936. *Air and Space Museum, Smithsonian Institution.*

A series of natural and man-made disasters plagued the community. With the popularity of the automobile, horse rendering became obsolete. In the 1920s, landfill from Jamaica Bay connected Barren Island to the Brooklyn mainland, and a young Brooklyn pilot, Paul Rizzo, created Barren Island Airport for early barnstorming daredevils.

City planners, seeking an airport site, took note and turned the construction of New York's first municipal airport over to the Department of Docks in 1928 as a central part of a proposed major transportation center in Jamaica Bay. In 1930, overflights by the Army Air Corps marked the airport's introduction to the public.

The airport was renamed for the late Floyd Bennett, Admiral Richard Byrd's co-pilot on his North Pole flights. On May 23, 1931, twenty-five thousand guests observed an armada of six hundred Army Air Corps planes led by Charles Lindbergh and James Doolittle.

In subsequent years, the WPA (Works Project Administration) and PWA (Public Works Administration) enlarged the runways and constructed hangars. For an international passenger terminal, the administration building with its control tower was enlarged. On the ground floor was a restaurant with a terrace dining area. Facilities for pilots to stay overnight occupied the second floor.

Because of its long, paved runways and landing lights, pilots chose Floyd Bennett Field for their competitive flights. In addition, a seaplane ramp allowed water takeoffs. Thousands of visitors watched the cross-country Bendix races and celebrities such as Amelia Earhart, Roscoe Turner, Wiley Post, Jacqueline Cochran and Eddie Rickenbacker. Howard Hughes set a

three-day, round-the-world record at Floyd Bennett Field, while Douglas Corrigan made history by flying the wrong way to Dublin instead of to California, for which he filed flight plans.

Although popular, Floyd Bennett Field never acquired the lucrative postal route needed to make an airport commercially viable, but it was noted for its clear weather patterns and better facilities. In over ten years of operation, Floyd Bennett handled a bit over 150,000 passengers—fewer than its rival Newark did.

From its initial stages, the Jamaica Bay vicinity interested the military. A seaplane base had been located in the Rockaways from 1917 to 1919. At Fort Tilden, the army had a hangar for an observation balloon. In 1931, the navy operated a reserve training center and expanded its facilities in 1937 and 1939. In 1936, the Coast Guard built an air station on the eastern side of the field. One of the first models of the Boeing B-17 "Flying Fortress" landed in 1937 for public inspection. As the war in Europe loomed, the navy expanded its space, adding to the seaplane base and building more support structures in 1940.

In 1942, the navy bought Floyd Bennett Field from the City of New York for $9,250,000, added a new runway and lengthened the landing strips. It was officially renamed Naval Air Station New York. World War II had begun.

With the outbreak of war, the navy turned Floyd Bennett Field into an armed camp. "Neutrality patrols" for "lend-lease" convoys flew from the seaplane facilities before war erupted. Effective May 1941, antisubmarine patrols operated out of the airport. Later, air ferry escort planes also flew from the base.

The Coast Guard also flew antisubmarine patrols and convoy support missions. In 1943, the first helicopter flight center emanated from the Coast Guard base there where the Sikorsky Company operated flight test facilities.

During World War II, barges loading aircraft and munitions in Jamaica Bay were defended by guns from Fort Tilden, as well as a dozen antiaircraft cannons at the Naval Station manned by soldiers from the army's Coast Artillery Corps. Other support antiaircraft batteries were stationed in the athletic field of Midwood High School, in Prospect Park, in Owl's Head Park, at Sea Gate and Manhattan Beach, as well as at Fort Hamilton.

After the war began, an additional seaplane hangar and runways were built in Jamaica Bay, along with piers for loading barges and freighters. At one point, an aircraft carrier docked in the bay.

Floyd Bennett became an early unit to utilize women in the military. The Women Airforce Service Pilots (WASP) ferried navy squadrons to

Floyd Bennett for shipment to foreign bases. Many planes were destined for foreign militaries and had foreign specifications as well as insignia. By February 1945, the base commissioned and ferried more than twenty thousand aircraft from the Naval Air Station.

In 1943, Floyd Bennett became the East Coast station for the Military Air Transport Service (MATS), handling 750 transcontinental military flights carrying five thousand passengers and 1 million pounds of cargo. At its peak in 1944, Floyd Bennett's Naval Air Station had three thousand navy personnel plus nearly a thousand civilians employed.

With the end of World War II in 1945, the airport continued its role as training ground for the military. As a Naval Air Reserve training station with thirty-four squadrons, it supported navy and marines in the Korean War. As the largest reserve training center in the country, it harbored twenty-seven U.S. Navy and Marine Corps squadrons, fourteen U.S. Air Force Reserve squadrons, nine Air National Guard squadrons, three Coast Guard sections and one U.S. Army antiaircraft unit.

As peace settled, the base still hosted a Marine Corps Air Detachment, a Naval Weather Environmental unit, the New York State Air National Guard, the U.S. Coast Guard Station and the New York City Police Aviation Bureau. In 1966, the National Guard built a new hangar.

In 1971, the Naval Air Station was decommissioned. The following year, Congress authorized creation of Gateway National Recreation Area.

With its transformation from a military base to a National Park operation, Gateway faces its greatest challenge to satisfy a variety of programs and interest. Yet the history of aviation and the role played by Floyd Bennett Field are not forgotten. Hangar B is the home for the Historic Aircraft Restoration Project in which volunteers work on antique planes to restore them to their original condition. Among the recent projects is the re-creation of Wiley Post's "Winnie Mae," a Lockheed Vega. Lectures on aircraft pioneers also are among the programs, including a history of Douglas Corrigan's "wrong-way" flight to Dublin.

PART VII

On the Waterfront

Our Waterfront Heritage

May 6, 2002

Brooklyn's history developed along its sixty-five-mile waterfront and then imploded to its interior. Before settlers moved to Brooklyn Heights, tradesmen had erected stores on the shores of the East River. Industries, lured by Brooklyn's natural harbor, built their shipping and, later, factories by the waterside.

The Erie Basin brought shipping into the Gowanus Canal. Fortress armaments, as well as early resorts, lined both sides of the Narrows. Transport barges used Coney Island Creek long before the seaside amusement parks blossomed. Sheepshead Bay, formerly a site for Native American wampum, changed in later years to a recreational fishing haven.

Brooklyn's past reliance on the waterfront for economy and entertainment anticipated its future usage. To help us understand the vitality of the neighborhoods that grew by the shoreline, the Brooklyn Historical Society published a series of four neighborhood history guides focusing on Brooklyn's northern industrial communities: Williamsburg; Greenpoint; Red Hook and Gowanus; and DUMBO–Fulton Ferry–Vinegar Hill.

Each of the publications has been thoroughly researched and written by Marcia Reiss, a former professor and journalist, and illustrated with classic photos from the society's files. A few contemporary photographs have been added for recognition and contrast.

The most recent of these gems is about the triple communities: DUMBO, Fulton Ferry Landing and Vinegar Hill. Today, these sections have been renovated and gentrified into some of the more desirable residential space in Brooklyn, but the earlier, colorful history of the area accompanied the lusty growth of Manhattan ferry traffic and the swelling of the Navy Yard from the Civil War period until the post–World War II doldrums.

Omitted from the DUMBO volume was reference to the Purchase Building, a Depression-era warehouse under the Brooklyn Bridge, now used as Mayor Bloomberg's crisis center. At production time, the future of

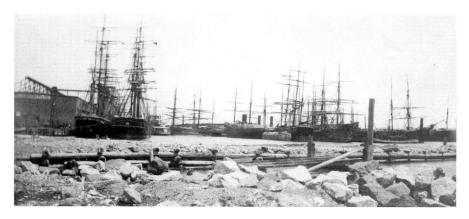

Sailing ships at Red Hook, circa 1880. *Brooklyn Historical Society.*

the building remained uncertain. The society planned the book for a "long shelf life," so the uncertainty doomed the reference. The same is true of the omission of the planned "Light Bridges" tower.

Brooklyn's history intrigues us. When General Washington escaped from a British onslaught in the Battle of Brooklyn, he embarked from the Fulton ferry piers. The history and freedom we celebrate so vociferously today dates back to these locations.

The first Union ironclad warship, the *Monitor*, designed by John Ericsson, was sent to the Navy Yard to be outfitted for battle. The waterfront lent itself to industry and "black arts," so named because of black soot from the factories developed along Greenpoint's waterfront: glassworks and pottery factories, bronze and iron foundries and petroleum refineries. But as our sensitivities to the environment increased and production cleaned up, Greenpoint evolved into a residential refuge for former workers and artists, many with Polish roots.

Williamsburg, Greenpoint's northern neighbor, grew as an independent city before it was annexed by the City of Brooklyn. From a haven for the rich, it evolved into a center for German settlers, who brought their culture and the beer industry to Brooklyn. Then the Williamsburg Bridge opened and a prosperous middle-class community emerged, followed by tenements where Jews and Italians worked and lived together. Today, a Hispanic community and a plethora of artists have joined the popular waterfront neighborhood.

Red Hook and Gowanus, the focal point of the Battle of Brooklyn, thrived because of the Atlantic Basin and Gowanus Canal. Both made the western port a vital shipping center. With the pollution of the Gowanus Canal and the collapse of Brooklyn's shipping center, Red Hook sank in social esteem,

surfacing as the nadir location of the controversial 1964 Hubert Selby Jr. novel, *Last Exit to Brooklyn*. Then a renaissance blew in, transforming Civil War–era warehouses into shops, a barge into a museum and the canal into pure water.

These booklets are crammed with many facts about the communities that usually remain the provenance of historians and researchers. But Marcia Reiss, an advocate for waterfront parks, has uncovered their history.

Meanwhile, Ms. Reiss is completing *Brooklyn Then and Now*, comparative photographs of Brooklyn sites.

Bridges to Brooklyn

September 22, 2005

As part of one of the three islands that compose New York City, Brooklyn has had to circumnavigate its surrounding waters. First it was by rowboat and then ferries, but now it is over bridges. Even the car-carrying ferry to Staten Island no longer transports automobiles.

In 1642, Cornelius Dircksen and his rowboat ferried the first passengers over the East River between Breuckelen and Nieuw Amsterdam. In 1693, Kings Bridge connected the Manhattan lands bordering Spuyten Duyvil Creek for a fee, but it soon collapsed. Manually operated ferries became the prime water transportation as competing companies built their piers throughout the Dutch and British administrations. By the time Americans assumed responsibility in 1788, the first idea of a bridge between Manhattan and Brooklyn was broached. But it was only talk. Reality was far in the future.

As an archipelago, the cities of Brooklyn and New York needed to deal with water transportation since their inception. Today, with 2,027 bridges throughout New York City, 76 are over water. The balance can be found in parks, as rail trestles or on private land. But without the means to construct strong bridges over wide and powerful rivers, other water conveyances prevailed.

Initial steam power was applied to locomotives and then to ships. John Stevens developed an early steamboat in 1802, followed by Robert Fulton, whose *Clermont* steamed from Albany to New York in 1807. By 1814, Fulton had built a steam ferry, the *Nassau*, which began a regular route between Manhattan and Brooklyn, as well as the USS *Fulton*, the first steam warship. But the idea of a massive bridge still drove engineering minds to the drawing boards—and even to some practical applications.

Without laws to forbid experimentation, suspension bridges rose around tributaries of the Mississippi River. One such engineer was John Roebling, who manufactured wire cable. In 1848, High Bridge rose over the palisades

of northern New York City. Still standing, it remains the city's oldest surviving bridge. This gave Roebling an idea, and he studied New York and Brooklyn.

Roebling had built a suspension bridge, an unfamiliar technique at the time, and an aqueduct in upstate New York. Now he approached William Kingsley, publisher of the *Brooklyn Daily Eagle*, with the concept of two massive stone towers supporting a steel roadbed over the turbulent East River. When the river froze over in 1867, grounding ferries, the public demanded an alternative. By 1869, his New York Bridge Company had started work.

Ironically, John Roebling died as a result of a ferry accident, but his son, Washington, a Union colonel in the Civil War, took the reins. Three years later, Washington became an invalid after contracting the bends. His wife, Emily, bravely took on the construction responsibilities. A national event, the opening of the Brooklyn Bridge in 1883 attracted a massive fireworks display, as well as three governors, two mayors and the president of the United States. Now the cities of Brooklyn and New York merged. The ferries, however, refused to give up until 1942. Today they have returned, faster than ever.

Other waters begged to be conquered. In the 1890s, Erastus Wiman, a developer from Staten Island, suggested a bridge from his recently opened St. George ferry terminal to Coney Island, but shortly after he defaulted on his debts.

The next serious attempt became the Williamsburg Bridge, designed by Leffert Buck. Construction of the heaviest suspension bridge took only seven years, half the time it took to build the Brooklyn Bridge. It opened in 1903 and was nicknamed "the Jewish Passover" for all the Lower East Side residents who moved over to Brooklyn.

By 1909, the two-level Manhattan Bridge fit neatly between its two predecessors. Designed by Leon Moisseiff, both ends featured sculptures, but Brooklyn lost its treasures to modernization. The Manhattan Arch and Colonnade remain.

All the Brooklyn East River bridges carried vehicles and trains at one time. The Brooklyn Bridge started with a cable car, then a steam locomotive and, until the 1950s, trolley cars. Now only the Manhattan and Williamsburg Bridges carry trains.

The Narrows had always stymied engineers. In 1925, experts officially opposed erection of a Narrows bridge. But by 1959, the unthinkable was promoted by Robert Moses, and the two-level design of Othmar Ammann became reality in 1963. After pressure from the Italian community, the name of the first discoverer of the Narrows—Giovanni Verrazzano—was added, although a *z* was dropped.

Aside from the four major bridges, Brooklyn possesses sixteen other bridges, the oldest being the Carroll Street Bridge (1889), a retractile bridge crossing the Gowanus Canal. Five other bridges pass over the Gowanus, built from 1889 to the Hamilton Avenue drawbridge in 1942. Four bridges cover Newtown Creek; two cross Coney Island Creek. A pedestrian bridge built in 1892 across Sheepshead Bay was rebuilt in 1917. Now it must be repaired again after a sea wall collapsed recently. Other short bridges cross English Kills (Metropolitan Avenue Bridge) and Mill Basin.

The long Marine Parkway Bridge across Rockaway Inlet was opened by President Roosevelt in 1937 and was later renamed the Marine Parkway–Gil Hodges Bridge after the Brooklyn Dodger player. And yes, it replaced a ferry.

Visit us at
www.historypress.net